ESSEX
IN PHOTOGRAPHS

JUSTIN MINNS

AMBERLEY

First published 2020

Amberley Publishing
The Hill, Stroud
Gloucestershire, GL5 4EP

www.amberley-books.com

Copyright © Justin Minns, 2020

All images © Justin Minns except pages 33, 39, 40, 41, 52 and 74 © Justin Minns/
National Trust.

The right of Justin Minns to be identified as the Author of this work has been
asserted in accordance with the Copyrights, Designs and Patents Act 1988.

ISBN 978 1 4456 9036 0 (print)
ISBN 978 1 4456 9037 7 (ebook)

British Library Cataloguing in Publication Data.
A catalogue record for this book is available from the British Library.

Typesetting by Aura Technology and Software Services, India.
Printed in the UK.

ACKNOWLEDGEMENTS

First of all, my wife Johanna deserves a medal for not only putting up with everything that goes with being married to a landscape photographer, but for continuing to give me support and an honest opinion when I need it (and sometimes when I don't!). Without her, none of this would be possible.

Ever since childhood my parents have always encouraged both my creative side, my love of the outdoors and, more recently, the pursuit of a career as a photographer – I can never thank them enough.

Special thanks go to everyone at the National Trust for giving me the opportunity to photograph the wonderful parts of Essex that they care for and for kindly allowing me to use some of those images in this book.

Having the right equipment is essential and lens filters play an important role in both the technical and creative side of my photography, and I'm very grateful to the team at Lee Filters for all their help and support.

I'd also like to thank all of the people who have become friends through my workshops, camera clubs and on my various social media channels for all their support and encouragement.

Last, but by no means least, thank you to Angeline Wilcox and everyone at Amberley Publishing for giving me the opportunity to produce this book.

ABOUT THE PHOTOGRAPHER

Justin Minns is a professional landscape photographer, best known for his atmospheric images of East Anglia. In his work Justin strives to use the best light and conditions to capture the spirit and natural beauty of the landscape. The resulting images have been widely published and his clients include the National Trust and English Heritage.

Justin's work has been recognised in several major competitions, including the prestigious Landscape Photographer of the Year, with his images appearing on the cover of the accompanying book on two occasions.

An experienced photography tutor, Justin has been running his popular 1-2-1 and group landscape photography workshops in East Anglia for several years. He also runs workshops in the area for the National Trust,

Forestry Commission and the Royal Photographic Society and, further afield, he leads photography tours to locations around the world.

Essex in Photographs is Justin's second book. His first book, *Photographing East Anglia*, is a photographers' guidebook to the region and was published in 2019. He also regularly writes articles for photography magazines, with his articles and images having appeared in many photography titles.

Born and raised in Essex, Justin now lives in the Suffolk countryside with his wife Johanna.

www.justinminns.co.uk

INTRODUCTION

In a land where we are spoilt by the amount of beautiful scenery on offer, Essex is often overlooked by photographers, but look past the dubious reputation that television has rather unkindly burdened it with and you'll discover a county that is something of a hidden gem.

In the north the River Stour meanders along the border with Suffolk, passing through the Dedham Vale Area of Outstanding Natural Beauty (a lowland landscape of meadows and farmland) on its way to the sea. This is 'Constable Country', a landscape little changed since the time it was immortalised by the paintings of John Constable.

The Essex countryside, a patchwork of farm and woodland that is dotted with picture-postcard villages, quirky landmarks and ancient castles, flows south through the county, around urban areas all the way down to Epping Forest, an old royal hunting forest, which stretches like a great swathe of green across the border with London.

Essex is bordered to the east by the North Sea. With over 350 miles of shoreline and thirty-five islands, it has one of the longest coasts and the most islands of any county in Britain. It's golden sandy beaches draw the summer crowds, but away from the buzz of the seaside towns the coast quickly becomes a place of solitude – a wilderness of mudflats, salt marshes and twisting creeks, littered with old boats and creaky jetties where the peace is broken only by the calls of seabirds. Adding a sense of mystery are the occasional relics of a military past like the Martello towers scattered along the coast or the Second World War anti-submarine defences stretching out across the Thames.

In fact, Essex is steeped in history: the Romans, Vikings, Saxons and Normans have all left their mark here. Colchester, once the capital of Roman Britain, is the country's oldest recorded town; Northey Island, where Vikings and Saxons fought in 991, is the oldest battlefield in Britain; and at almost 1,000 years old, Greensted Church is the oldest wooden church in the world.

Growing up in the very north of the county, a stone's throw from Constable Country and the Suffolk border, I was already well acquainted with the north of the region, but photographing the rest of the county for this book has been a journey of discovery. I hope you enjoy the trip as much as I have.

SAND AND SEA

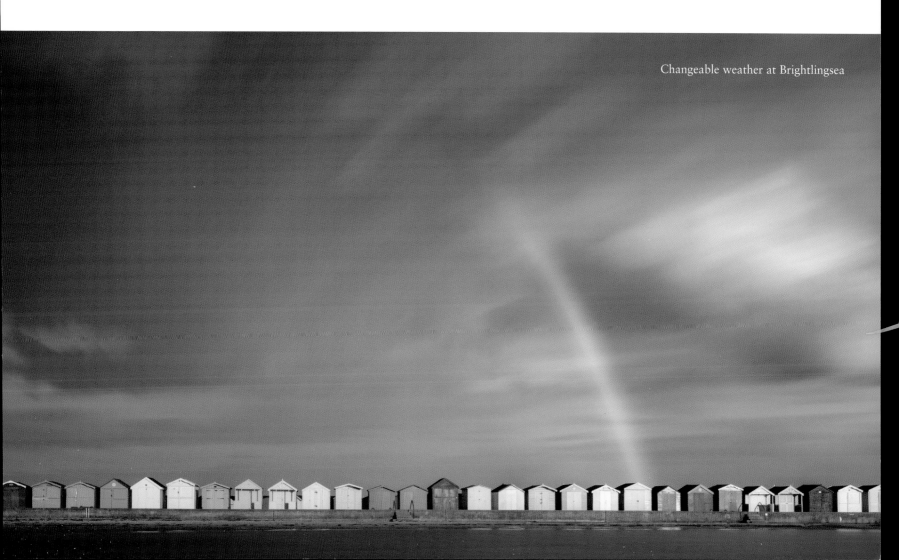

Changeable weather at Brightlingsea

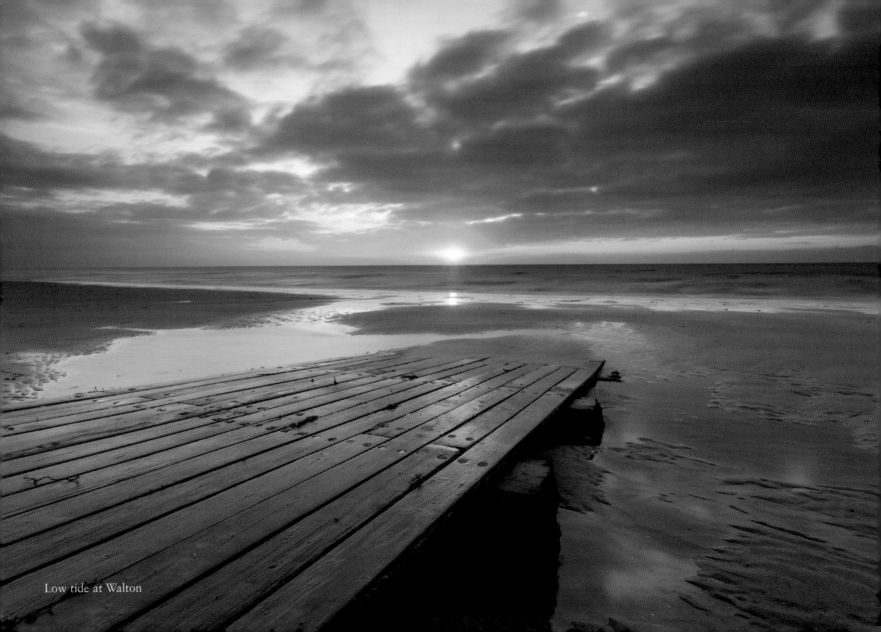
Low tide at Walton

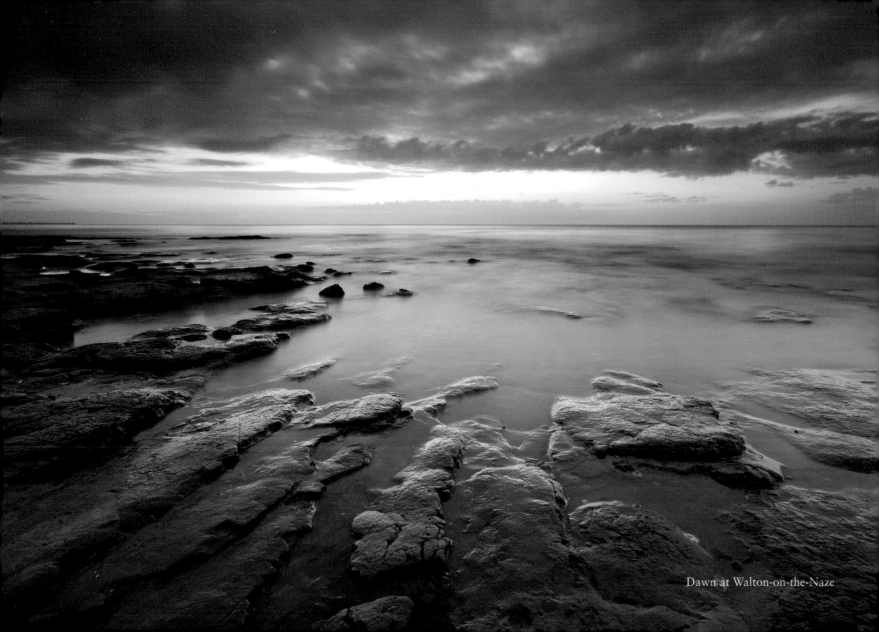

Dawn at Walton-on-the-Naze

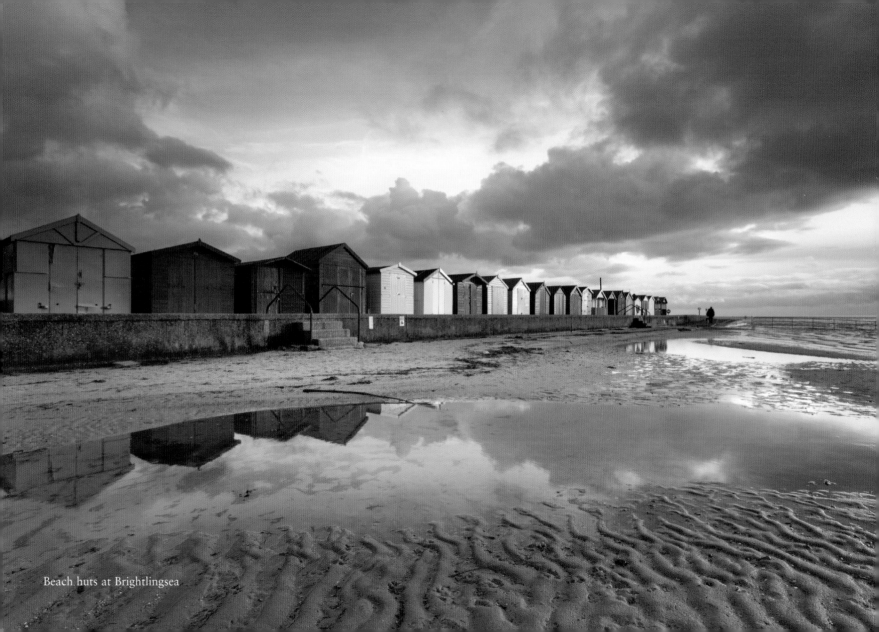

Beach huts at Brightlingsea

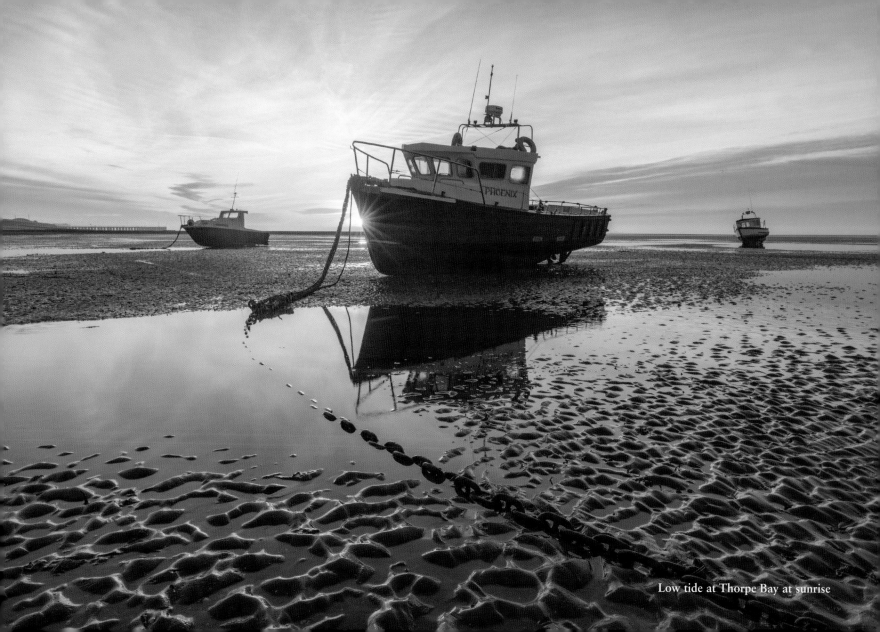

Low tide at Thorpe Bay at sunrise

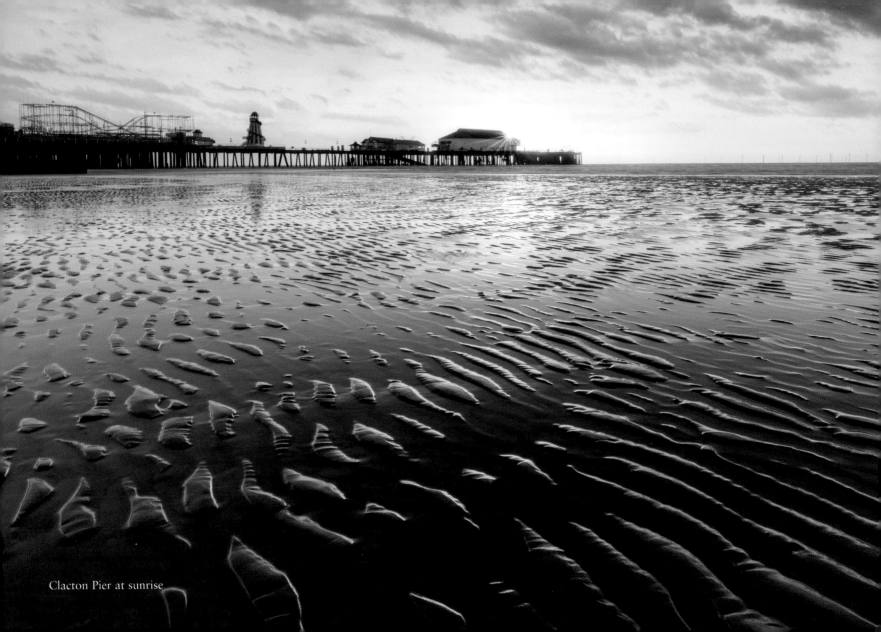
Clacton Pier at sunrise

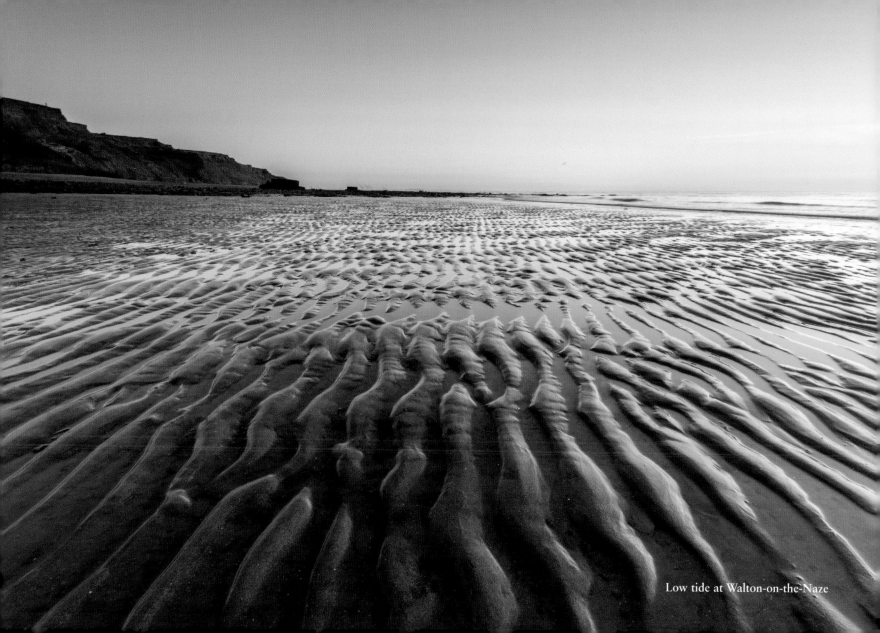

Low tide at Walton-on-the-Naze

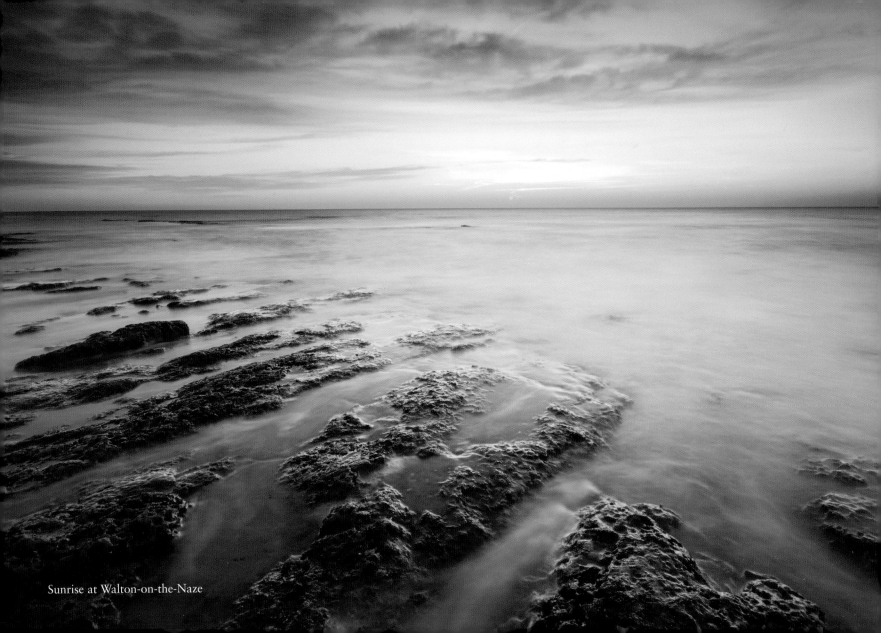

Sunrise at Walton-on-the-Naze

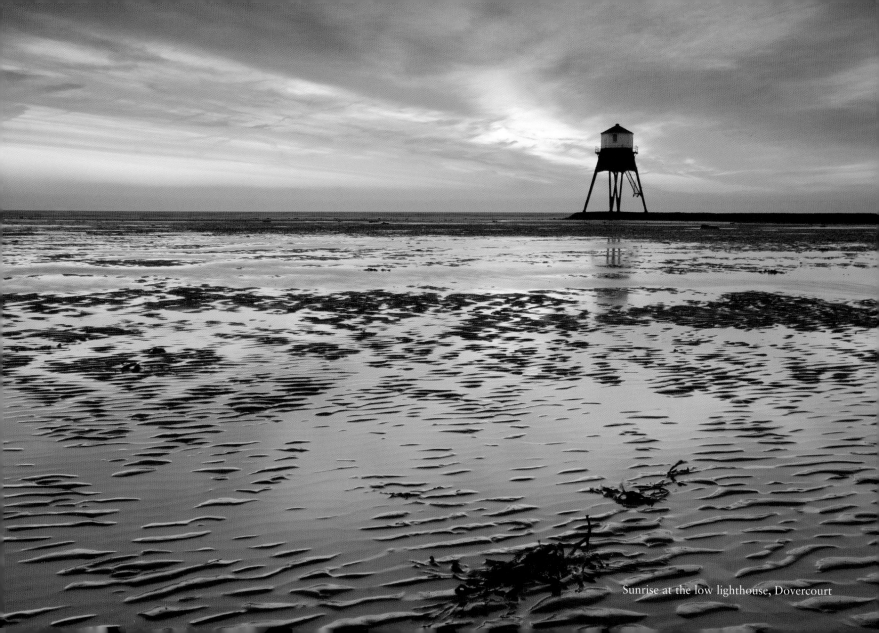

Sunrise at the low lighthouse, Dovercourt

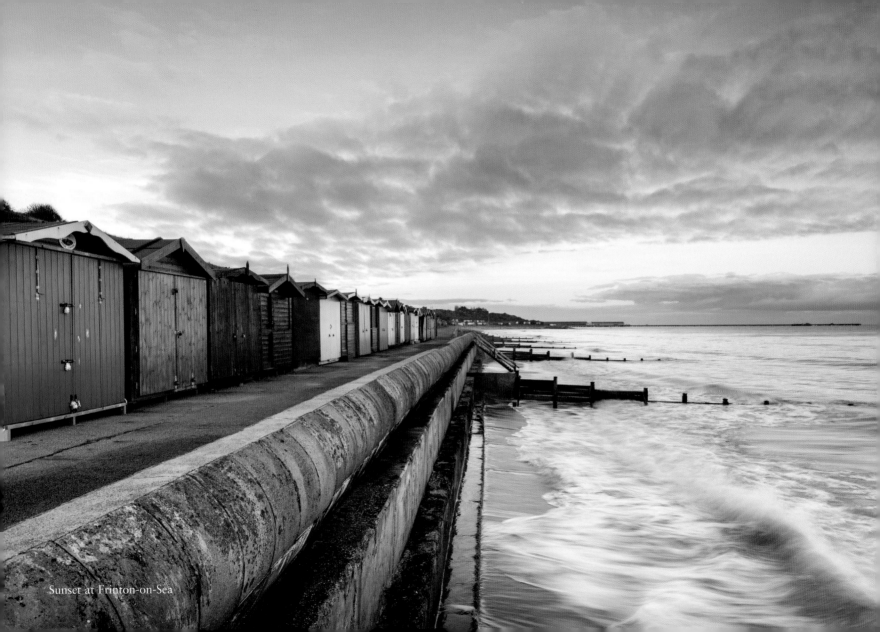
Sunset at Frinton-on-Sea

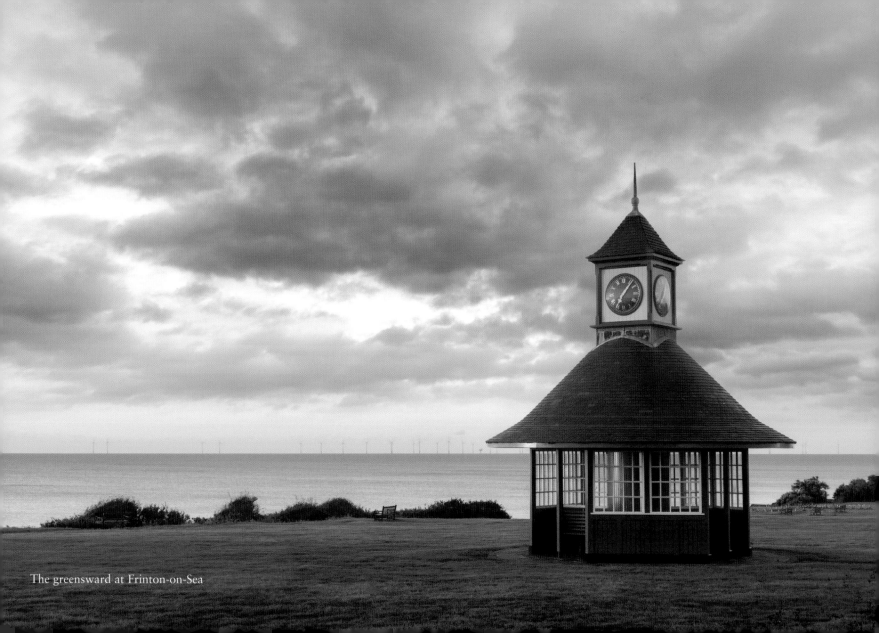

The greensward at Frinton-on-Sea

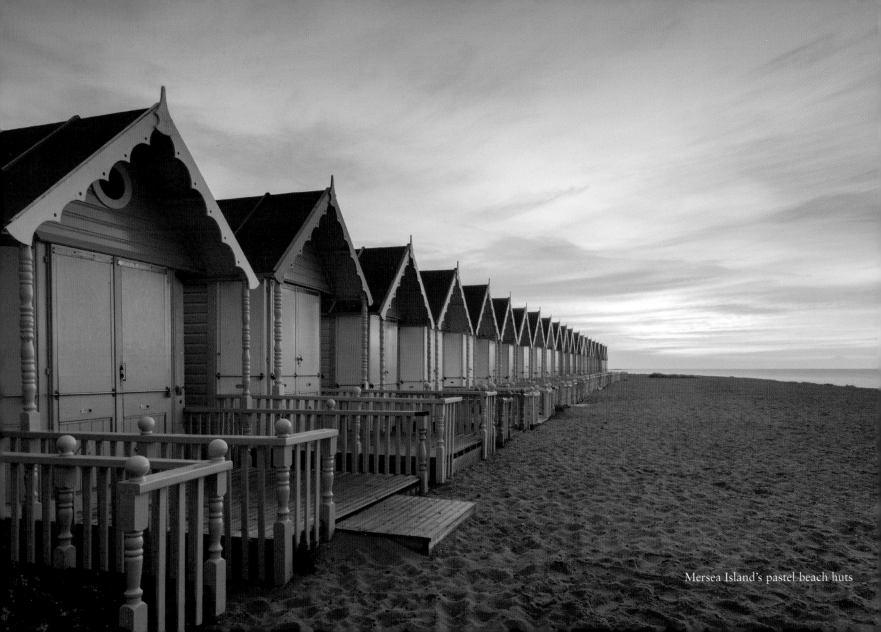

Mersea Island's pastel beach huts

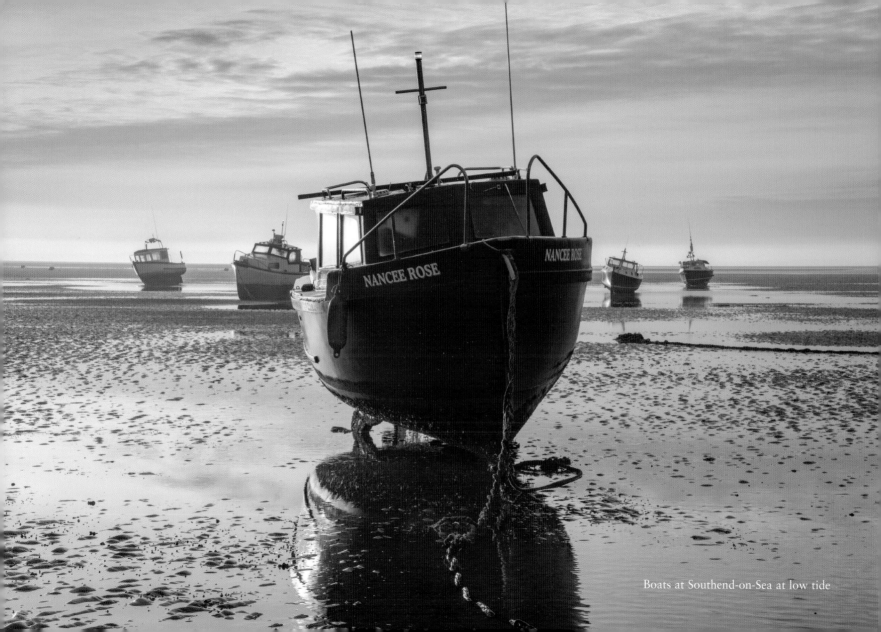

Boats at Southend-on-Sea at low tide

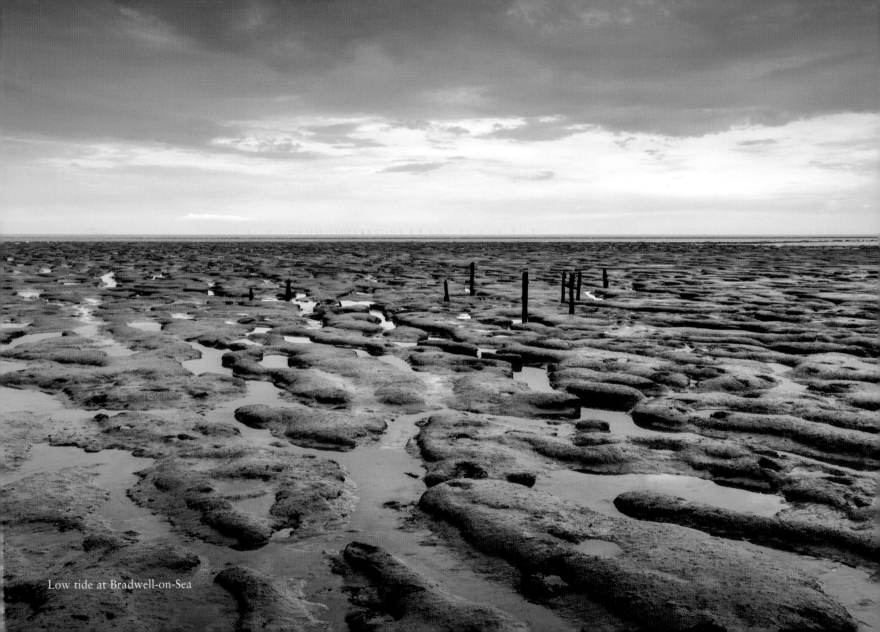

Low tide at Bradwell-on-Sea

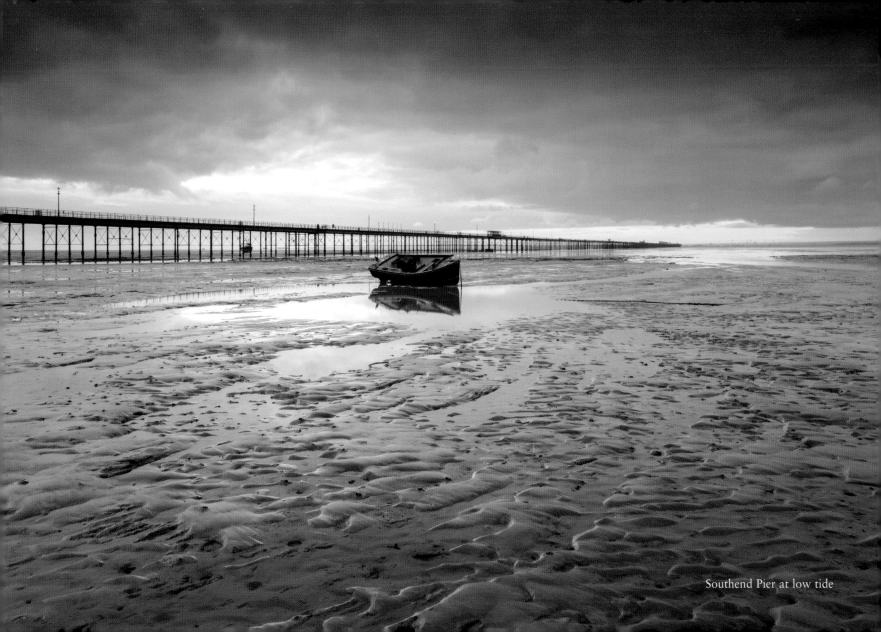

Southend Pier at low tide

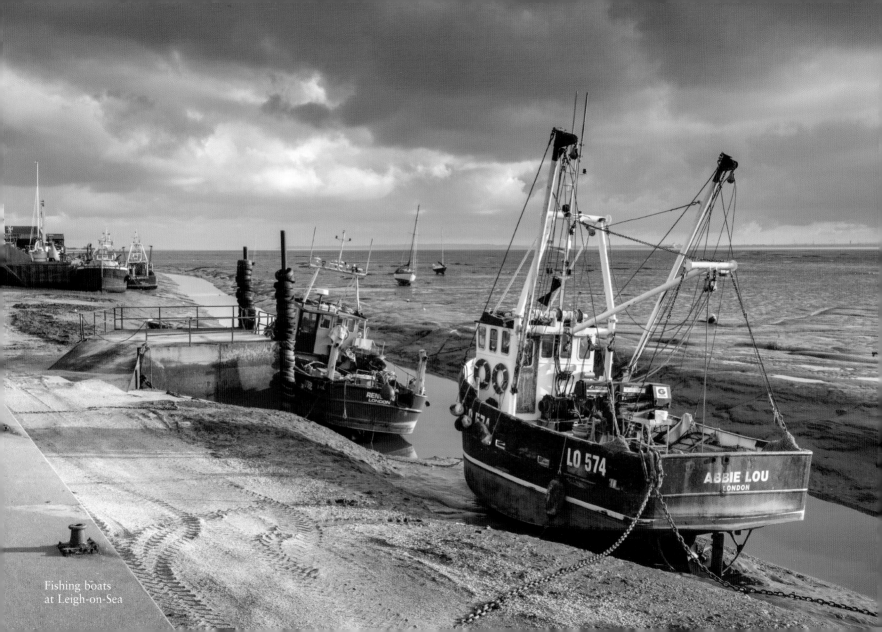

Fishing boats
at Leigh-on-Sea

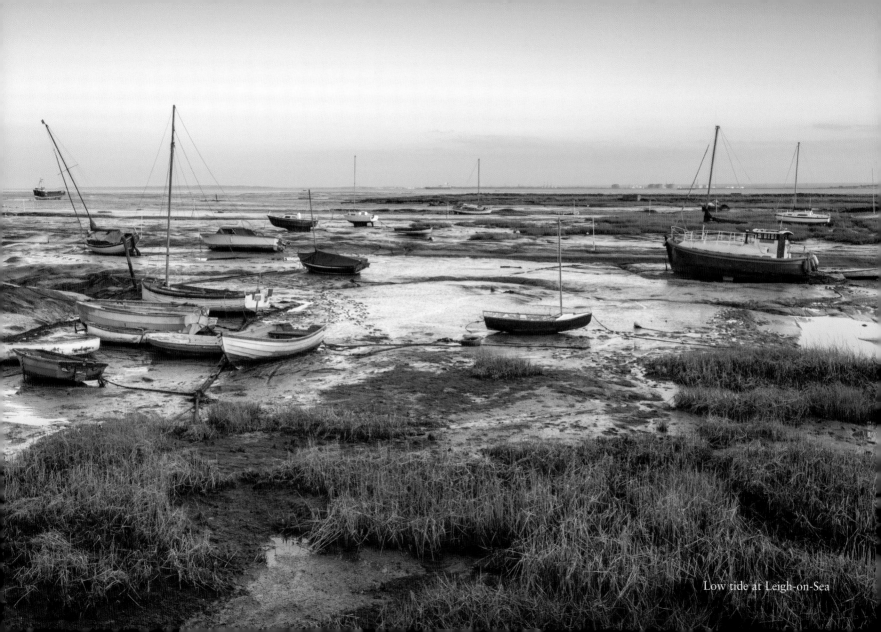

Low tide at Leigh-on-Sea

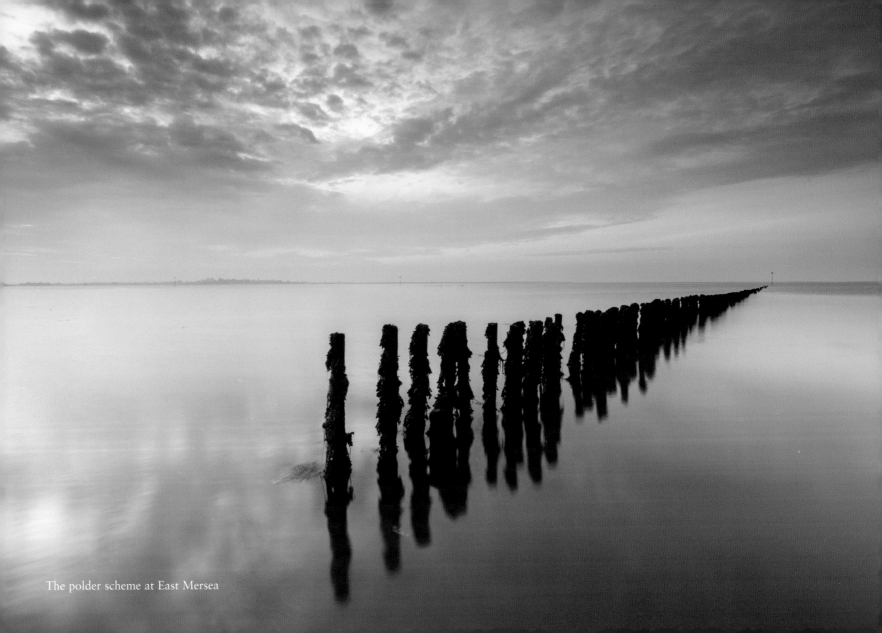
The polder scheme at East Mersea

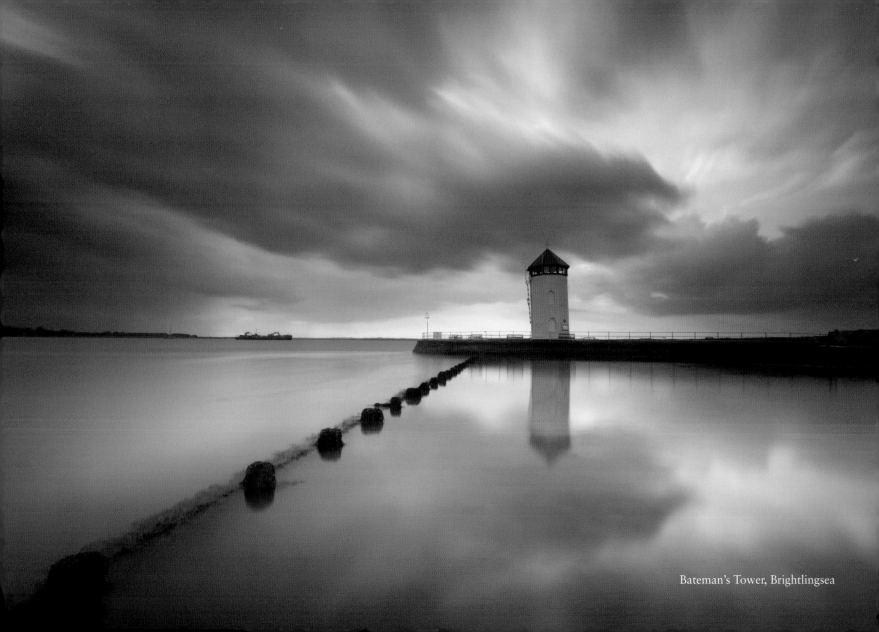

Bateman's Tower, Brightlingsea

High tide at Dovercourt Lighthouse

TOWN AND COUNTRY

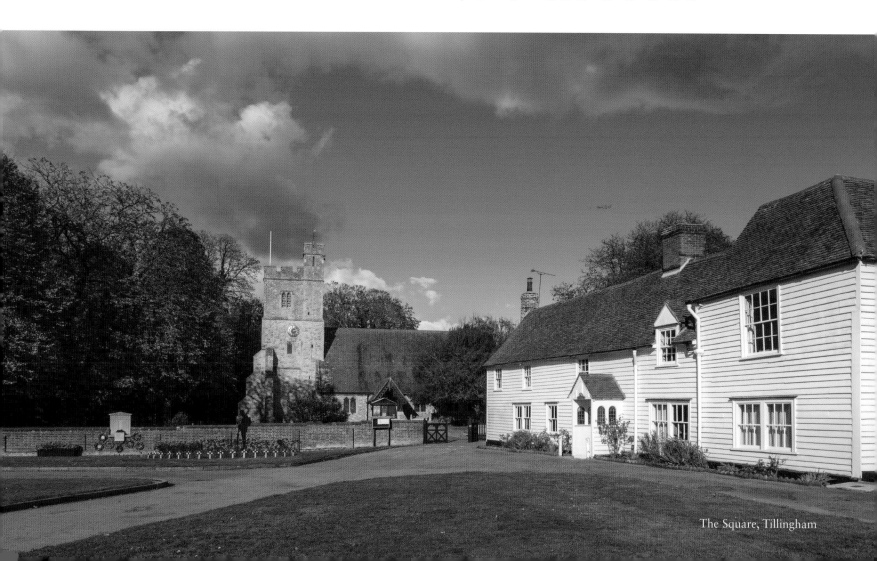

The Square, Tillingham

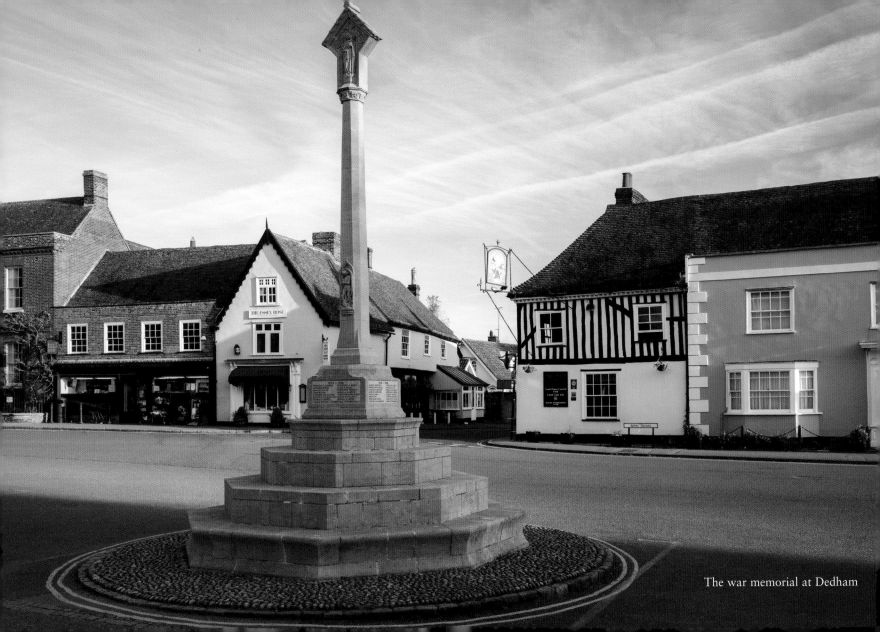

The war memorial at Dedham

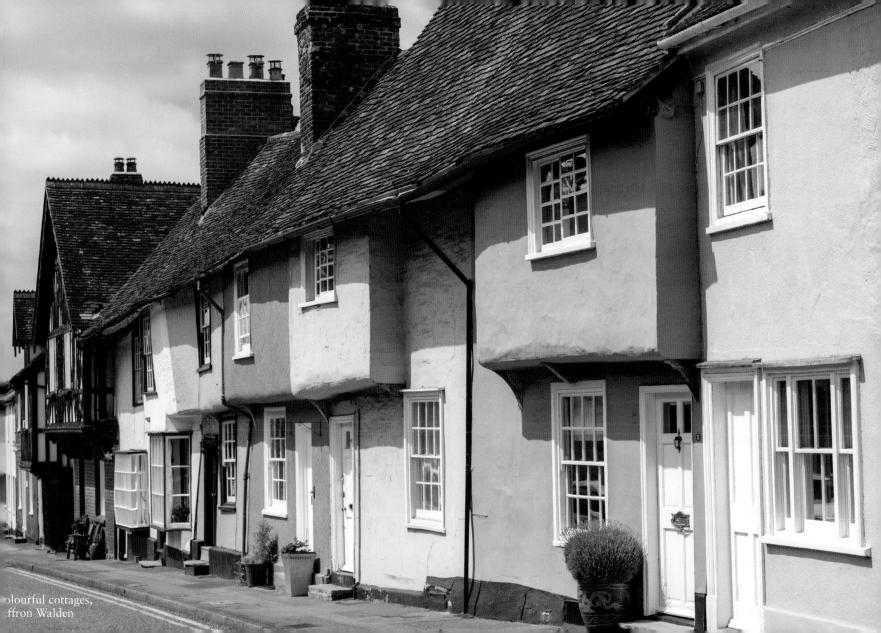

Colourful cottages, Saffron Walden

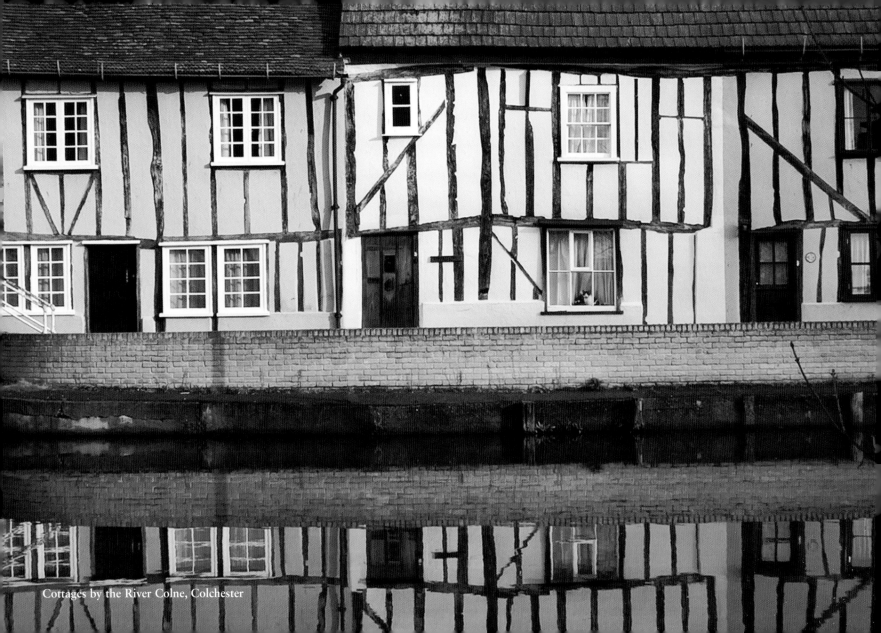

Cottages by the River Colne, Colchester

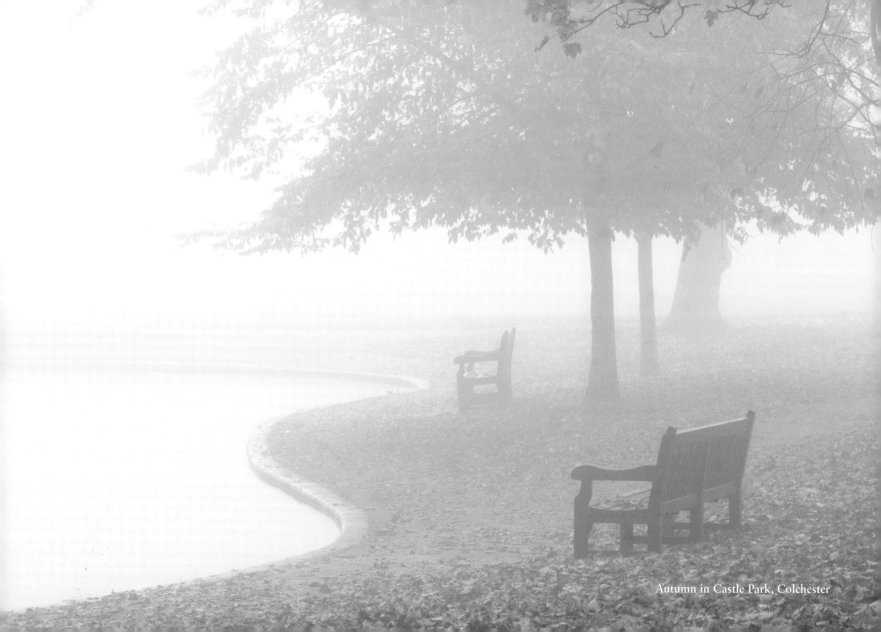

Autumn in Castle Park, Colchester

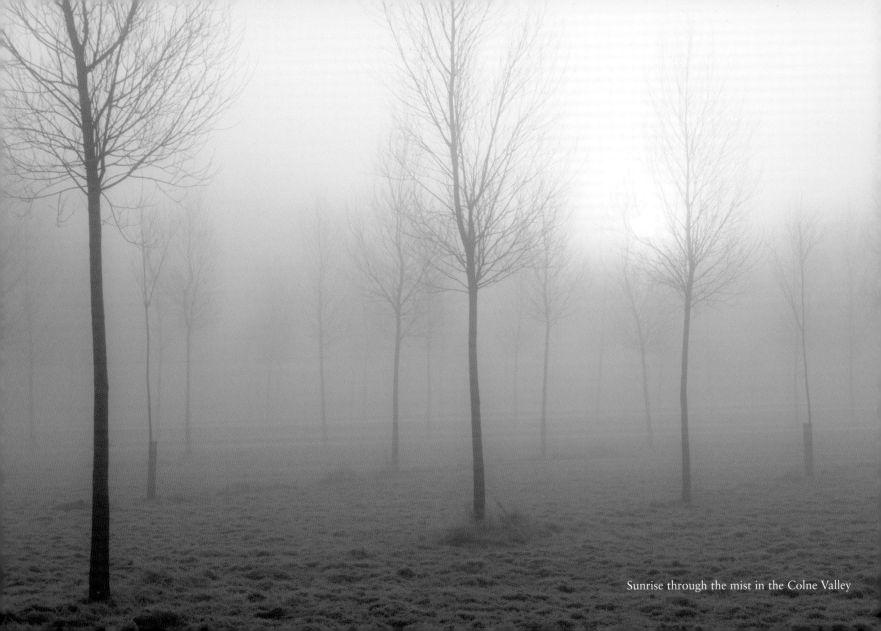
Sunrise through the mist in the Colne Valley

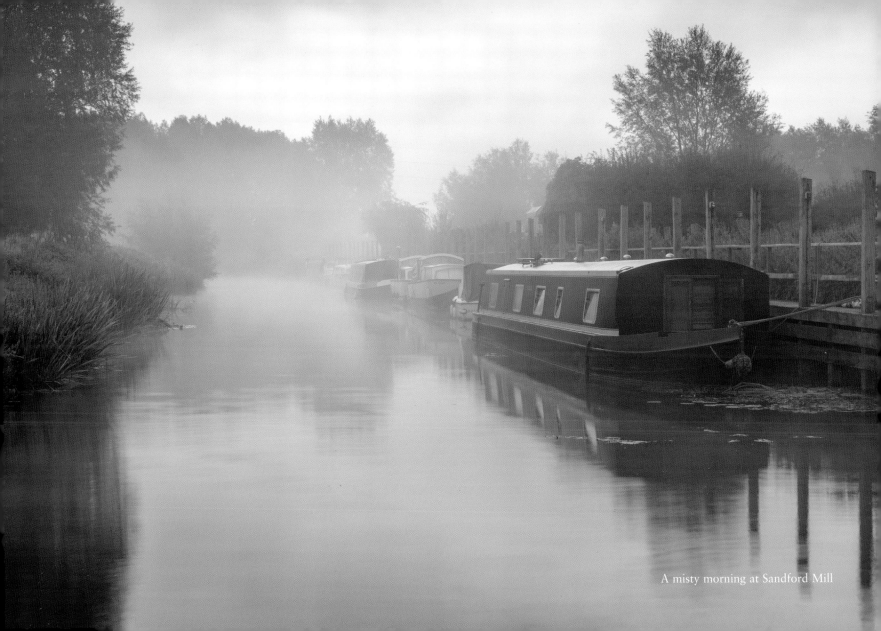

A misty morning at Sandford Mill

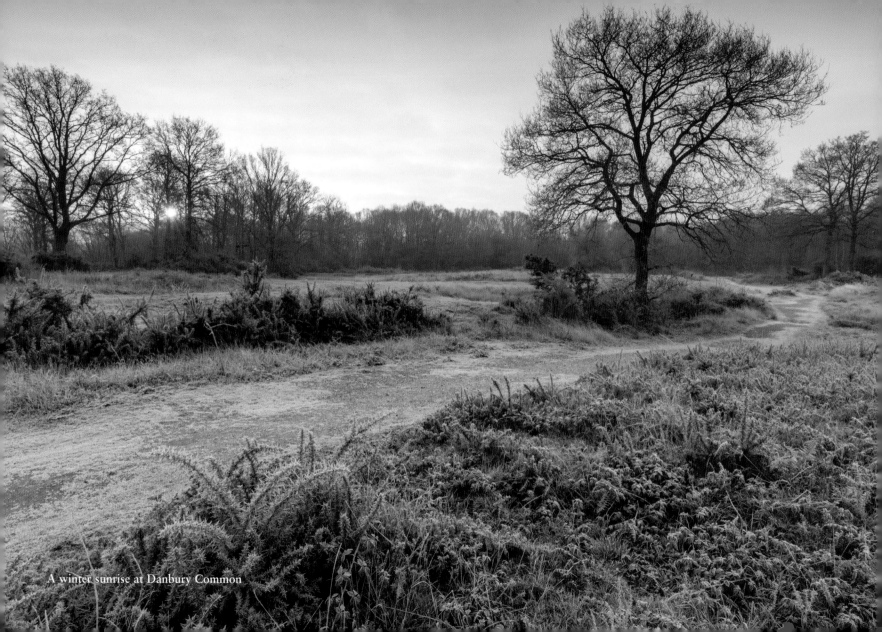

A winter sunrise at Danbury Common

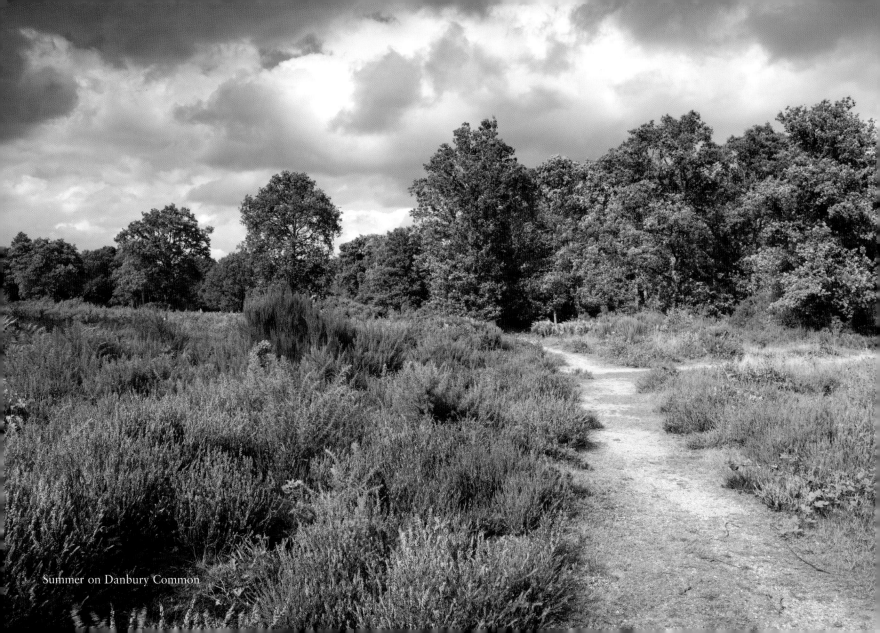

Summer on Danbury Common

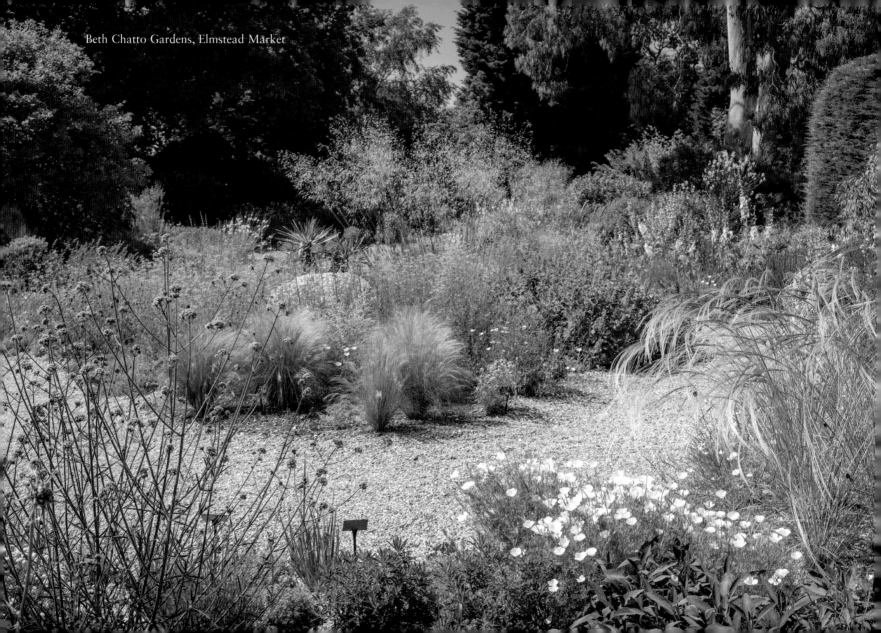

Beth Chatto Gardens, Elmstead Market

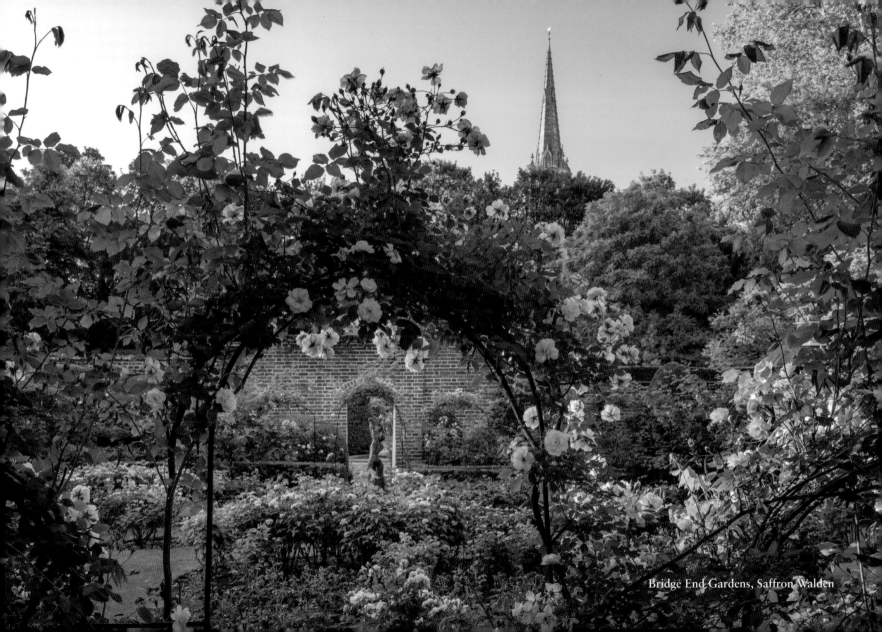

Bridge End Gardens, Saffron Walden

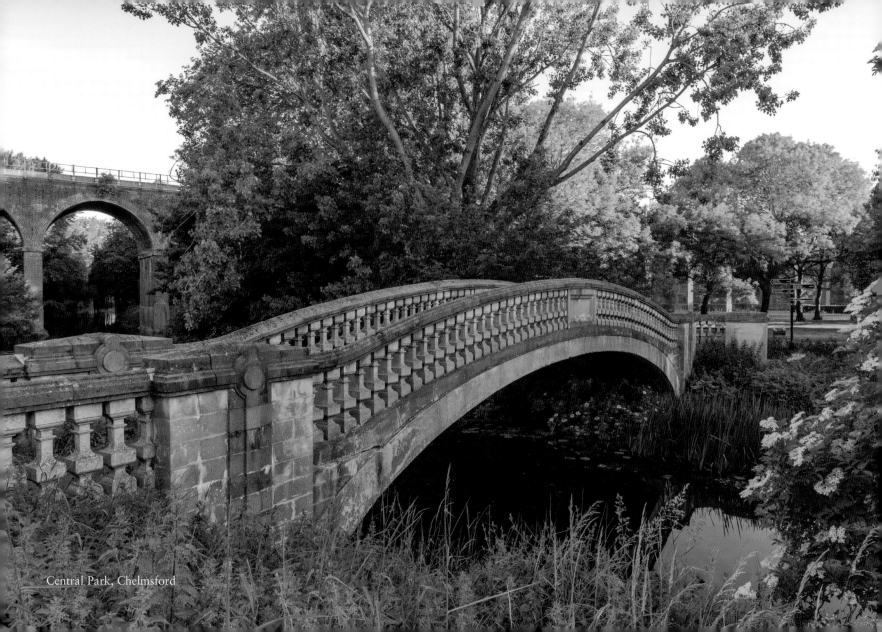
Central Park, Chelmsford

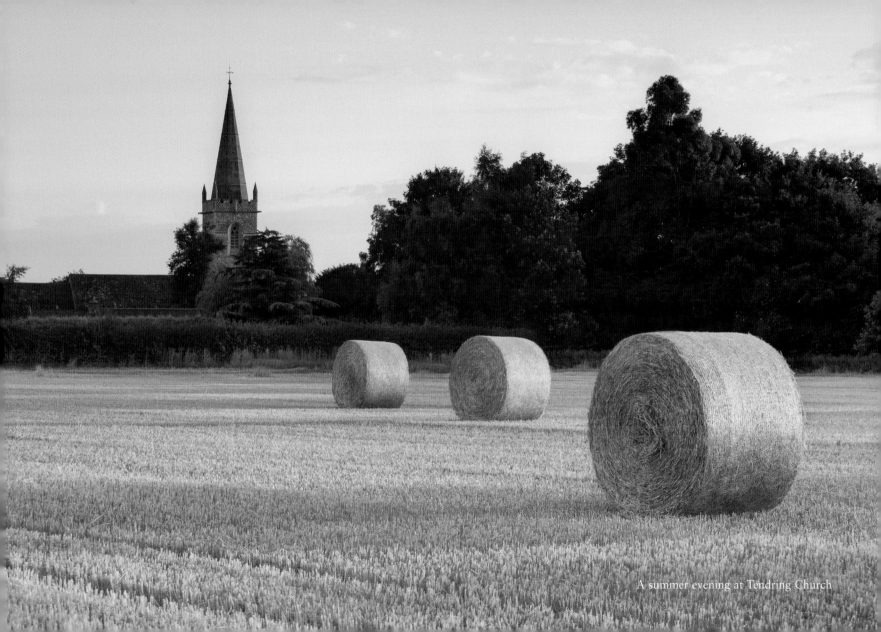

A summer evening at Tendring Church

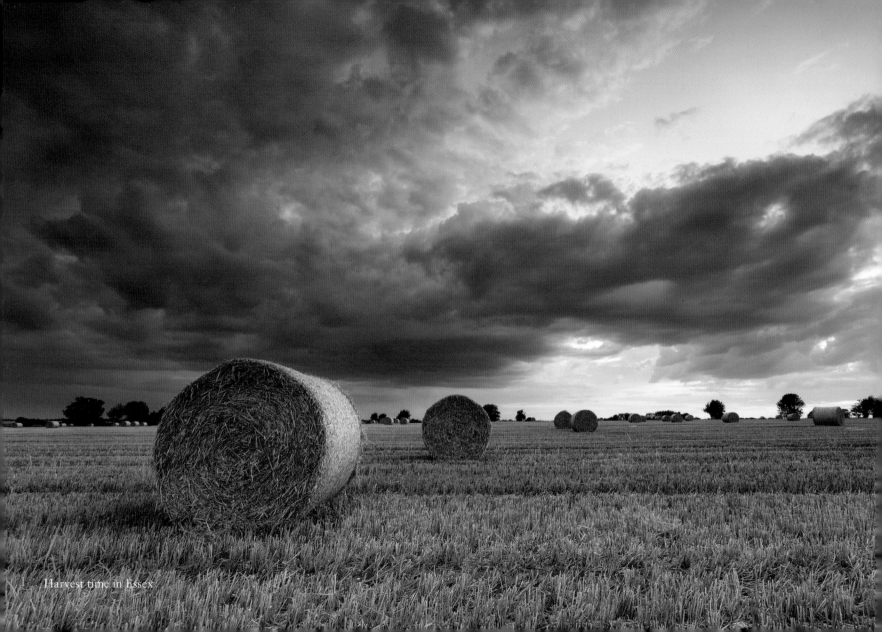
Harvest time in Essex

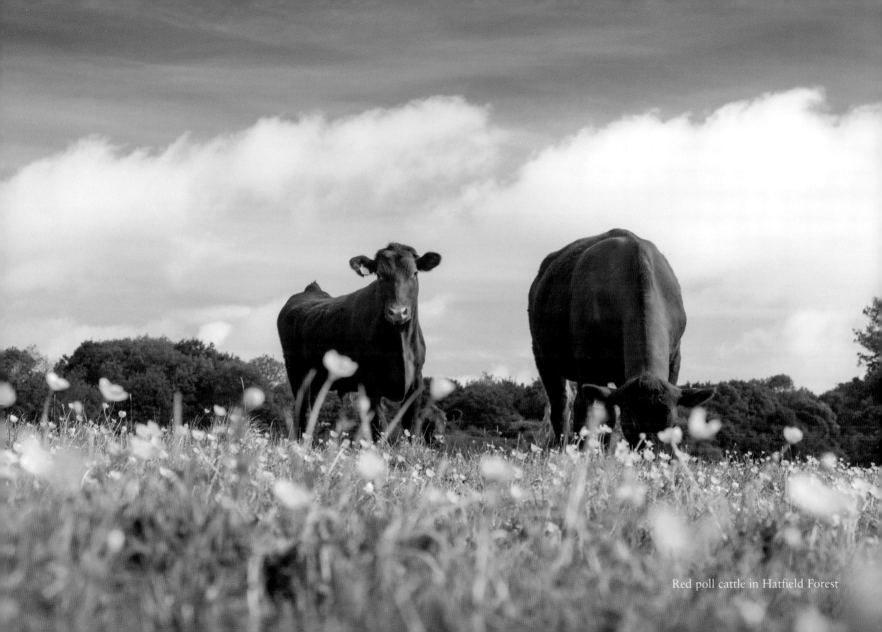

Red poll cattle in Hatfield Forest

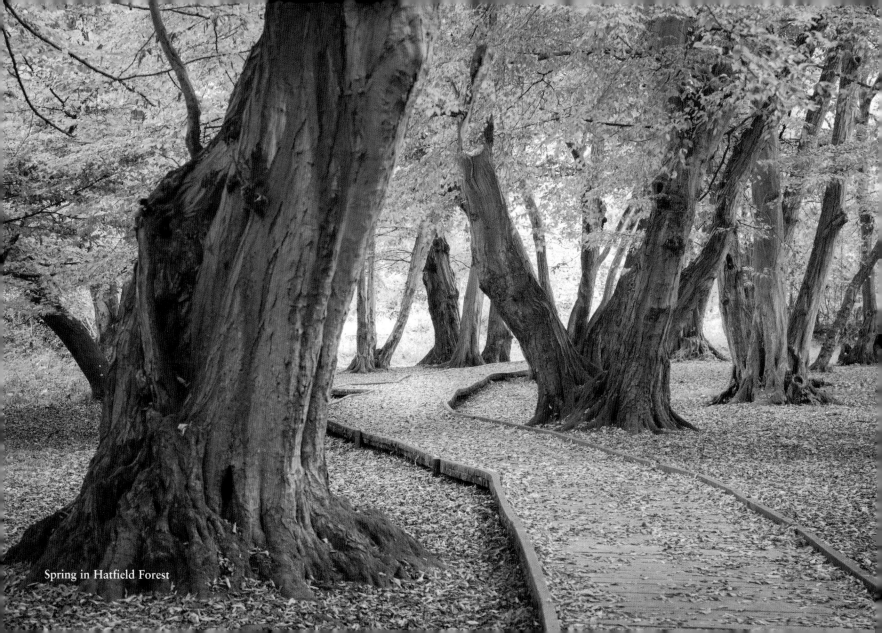
Spring in Hatfield Forest

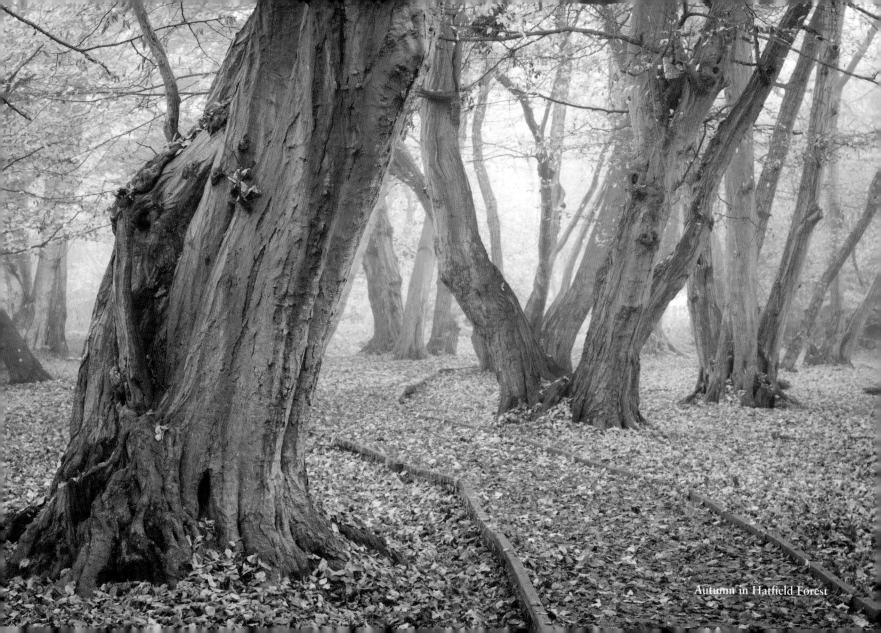

Autumn in Hatfield Forest

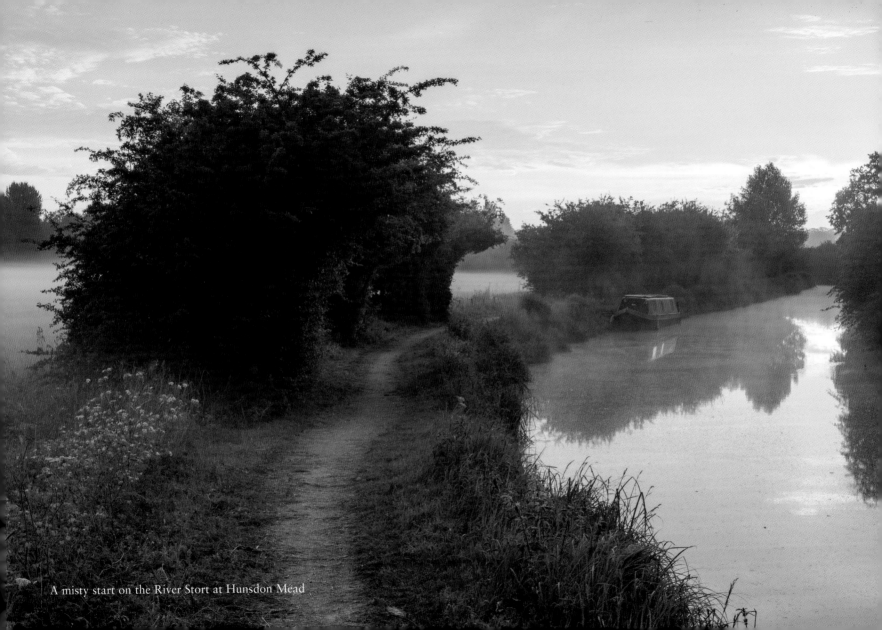

A misty start on the River Stort at Hunsdon Mead

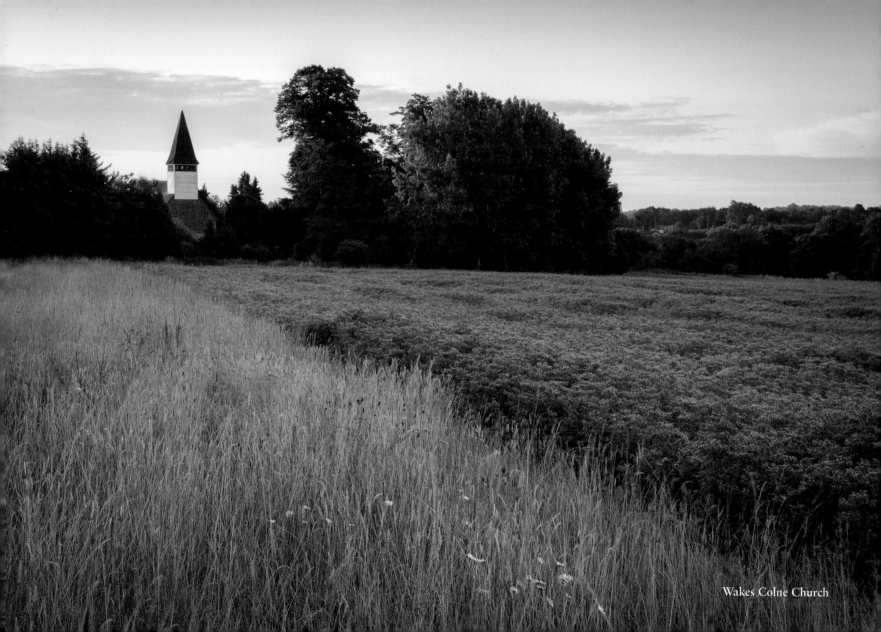

Wakes Colne Church

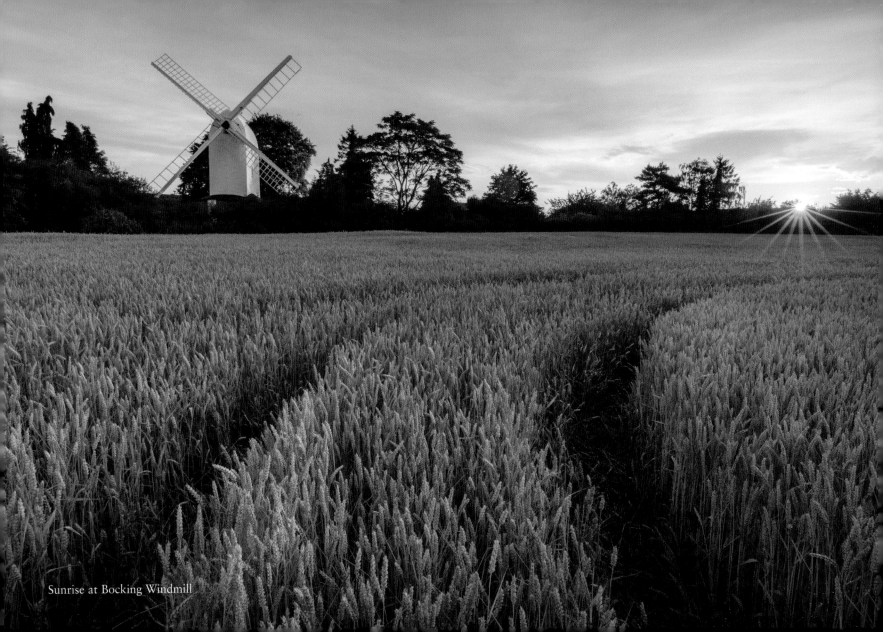

Sunrise at Bocking Windmill

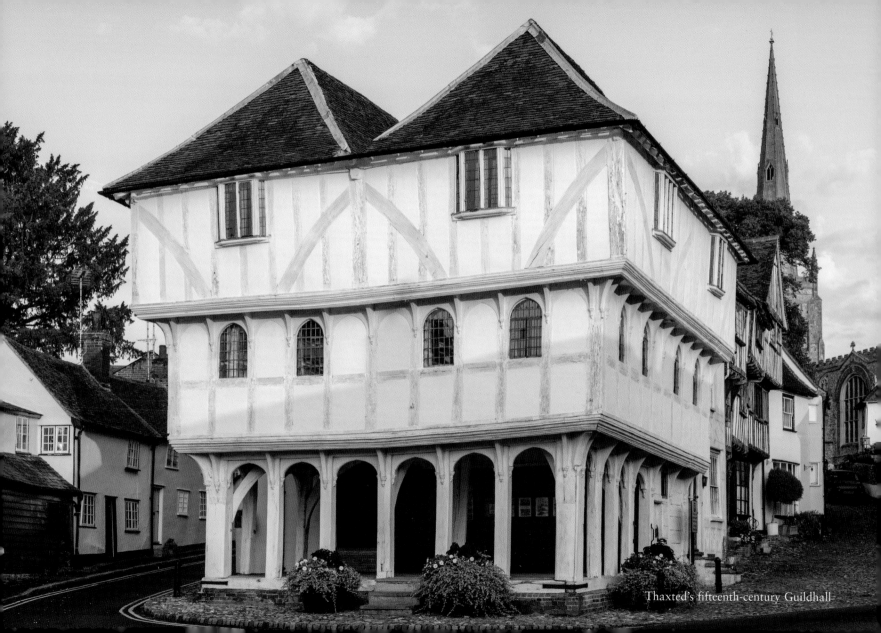
Thaxted's fifteenth-century Guildhall

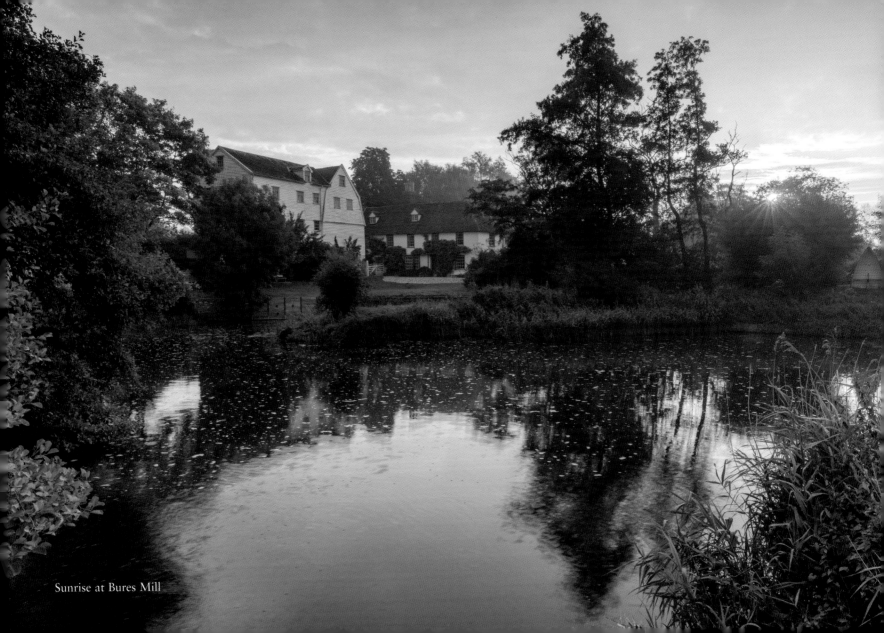

Sunrise at Bures Mill

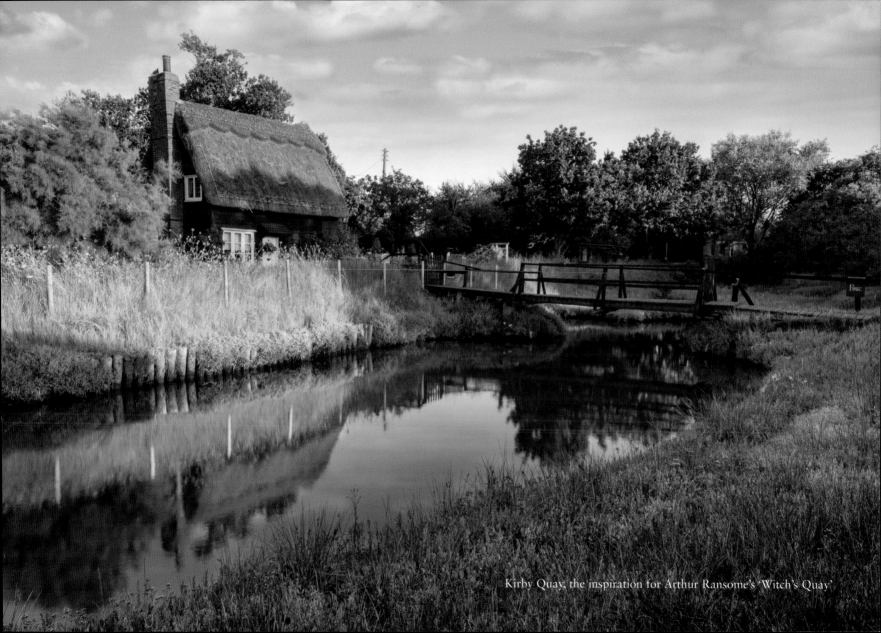

Kirby Quay, the inspiration for Arthur Ransome's 'Witch's Quay'

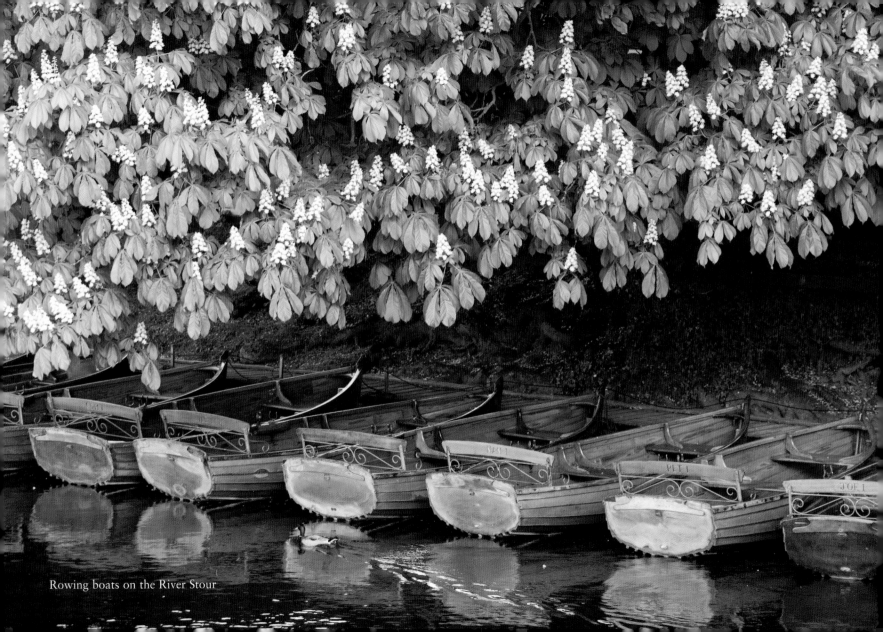

Rowing boats on the River Stour

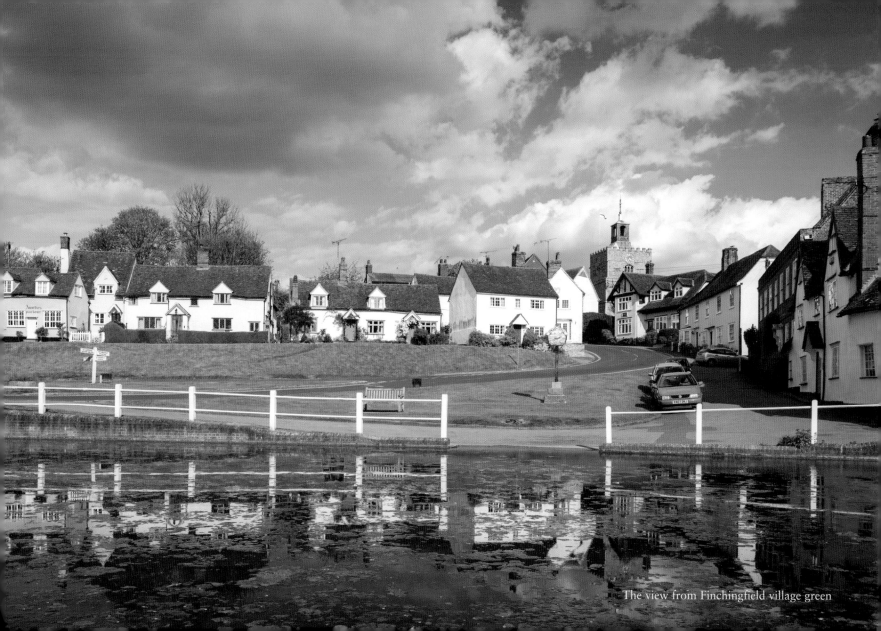

The view from Finchingfield village green

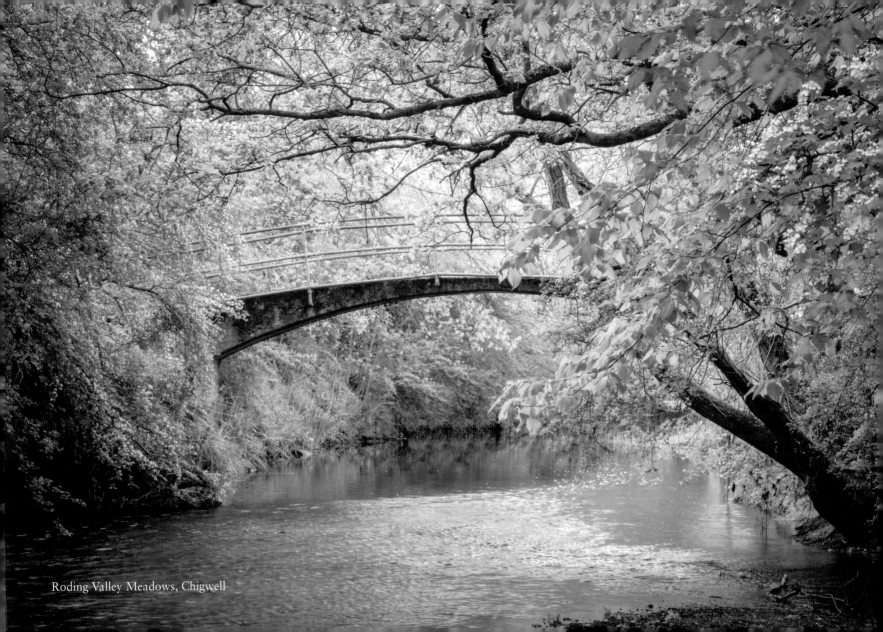
Roding Valley Meadows, Chigwell

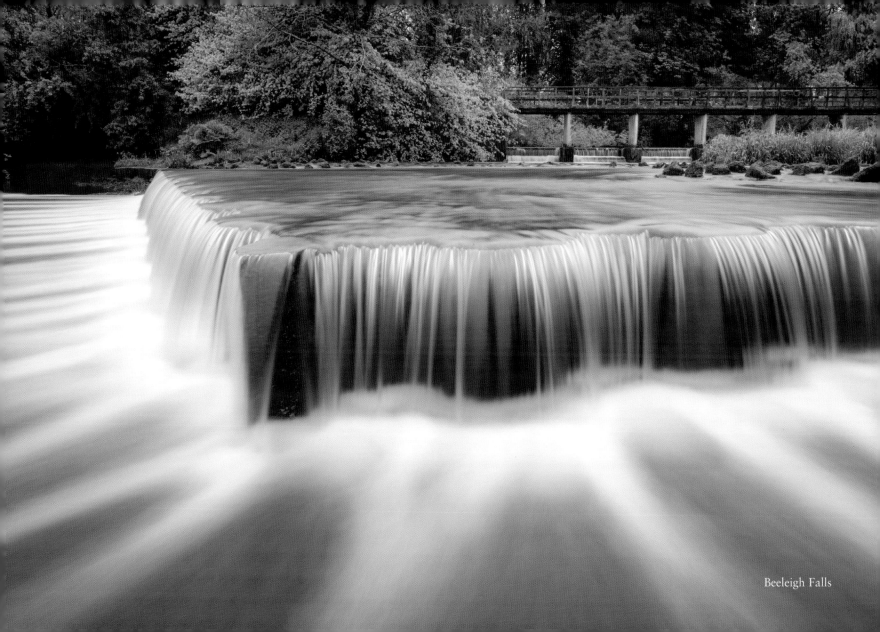

Beeleigh Falls

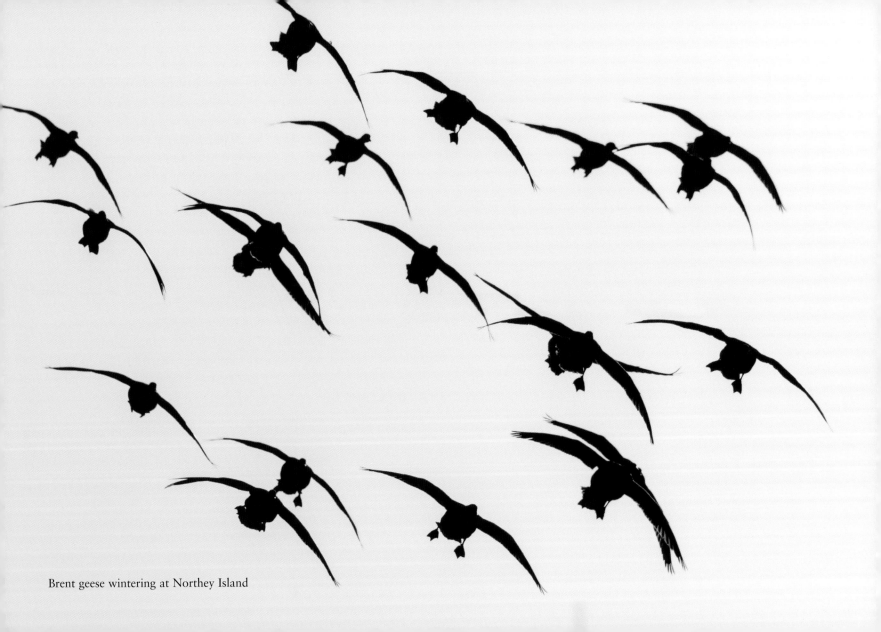

Brent geese wintering at Northey Island

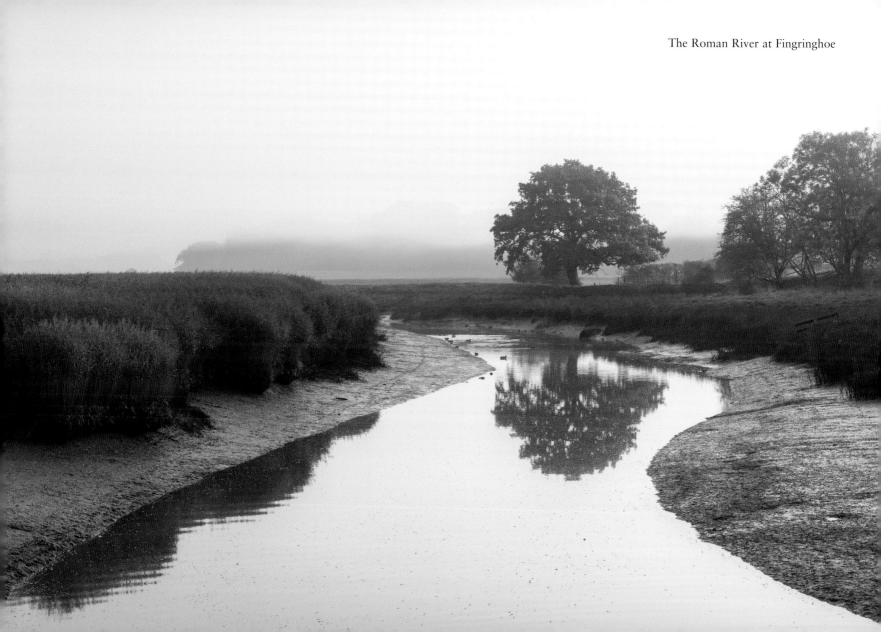

The Roman River at Fingringhoe

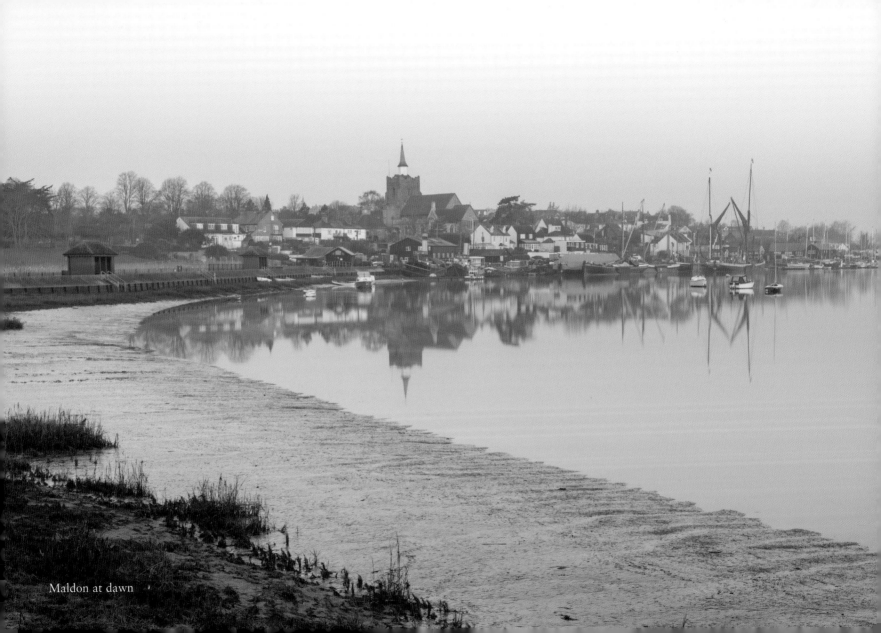

Maldon at dawn

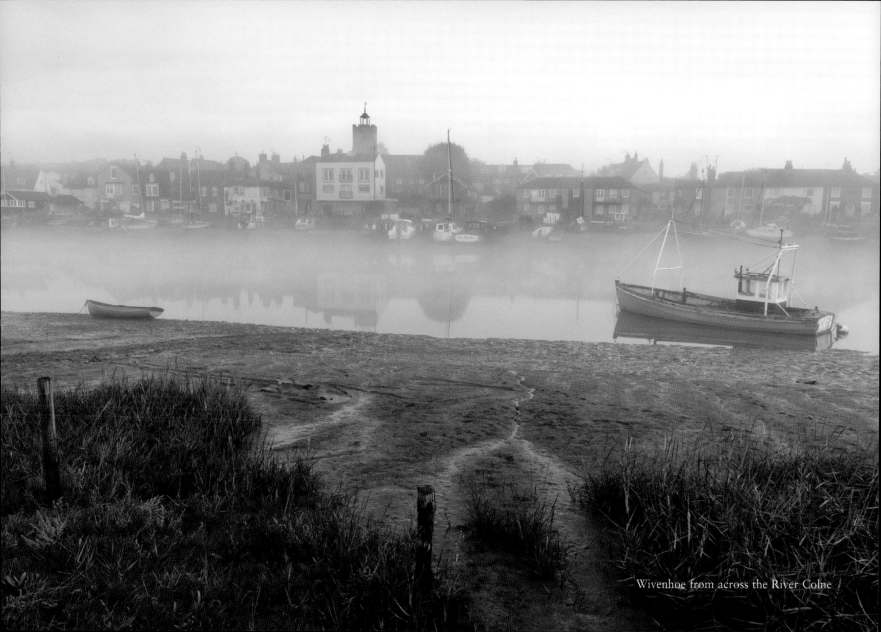

Wivenhoe from across the River Colne

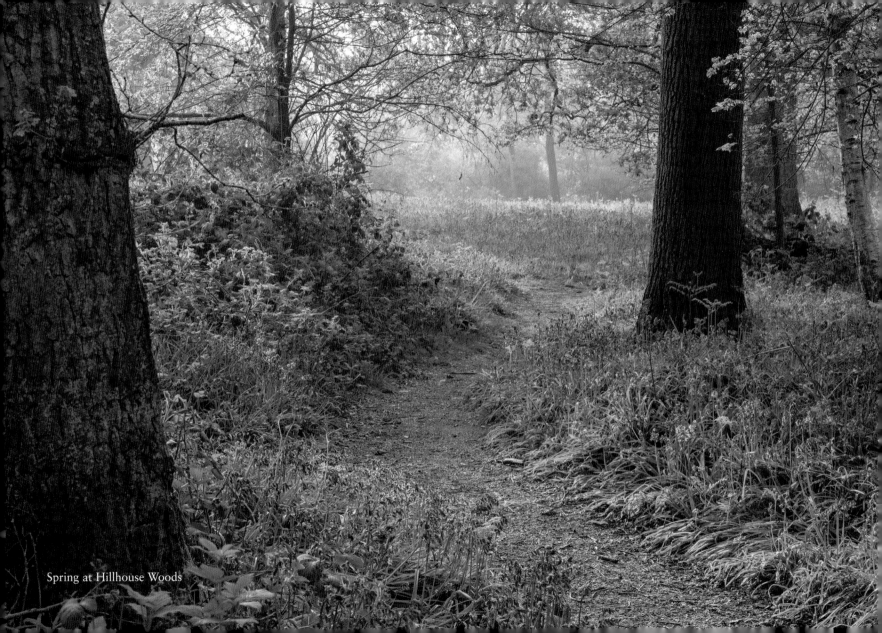

Spring at Hillhouse Woods

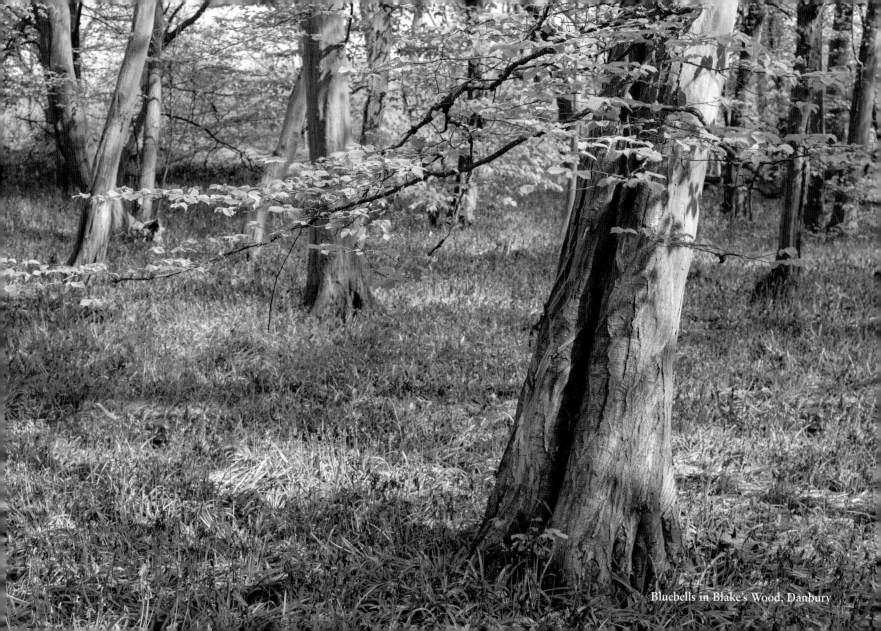

Bluebells in Blake's Wood, Danbury

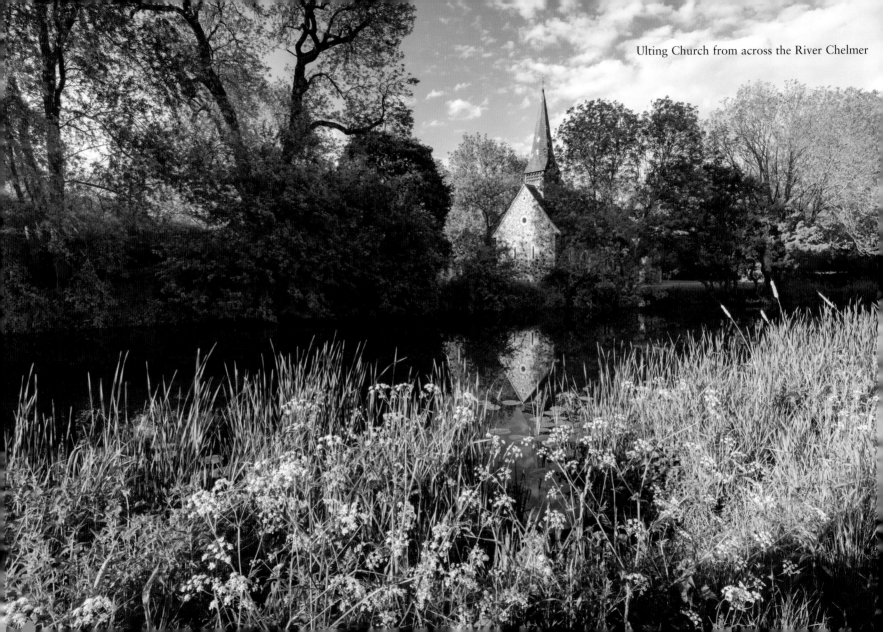

Ulting Church from across the River Chelmer

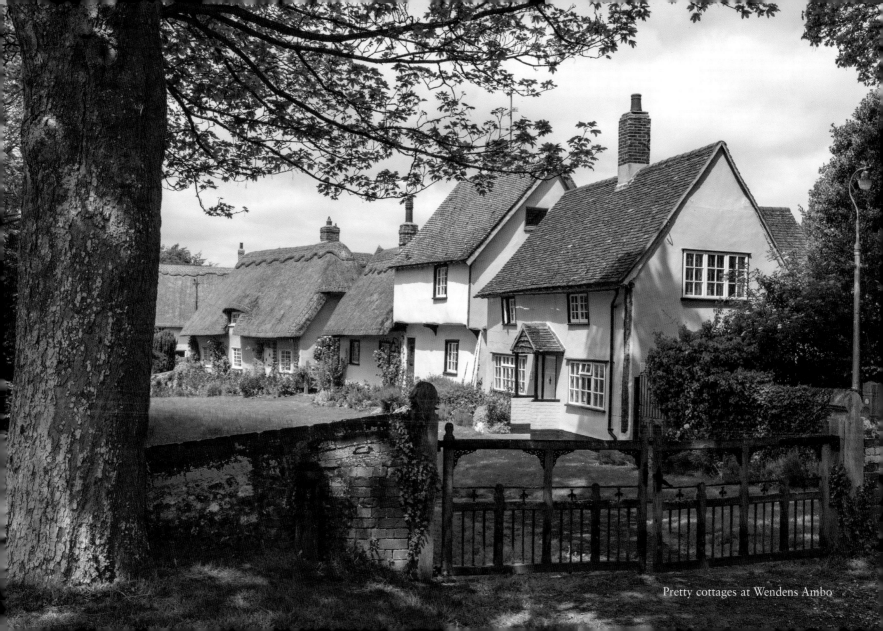

Pretty cottages at Wendens Ambo

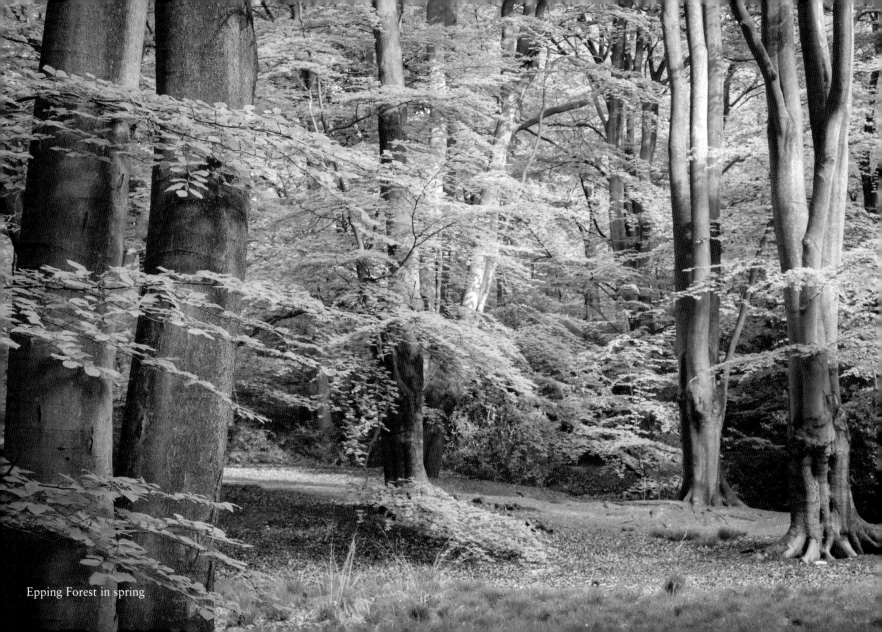

Epping Forest in spring

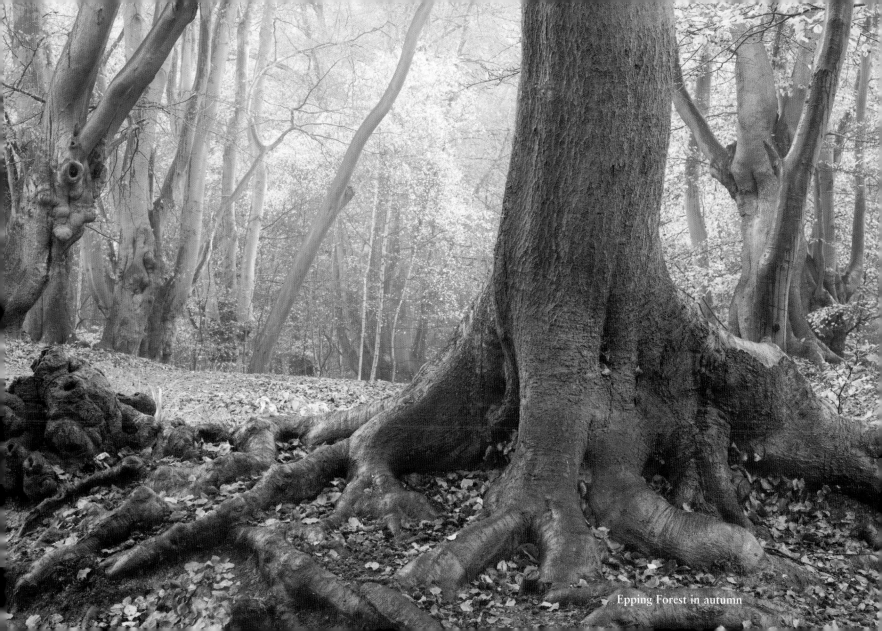

Epping Forest in autumn

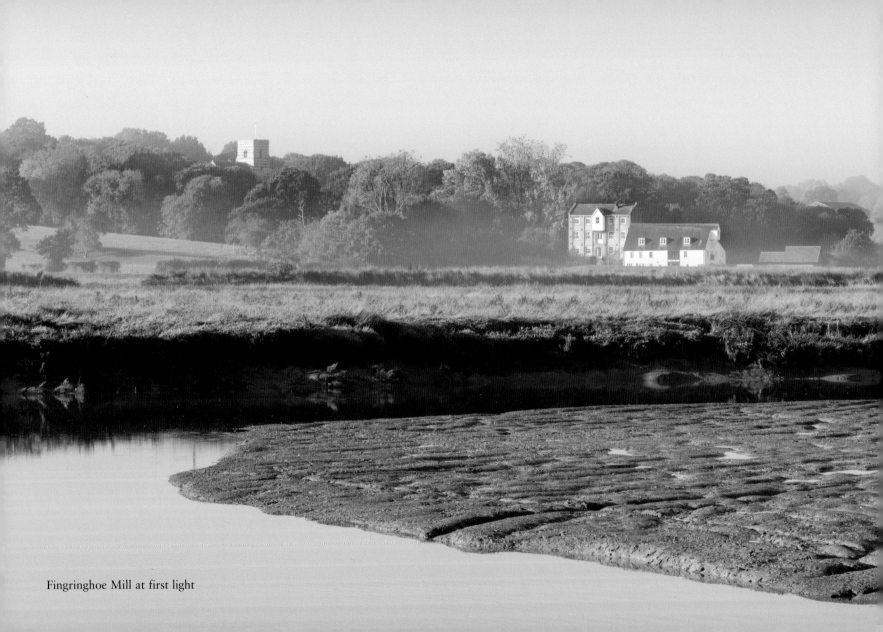
Fingringhoe Mill at first light

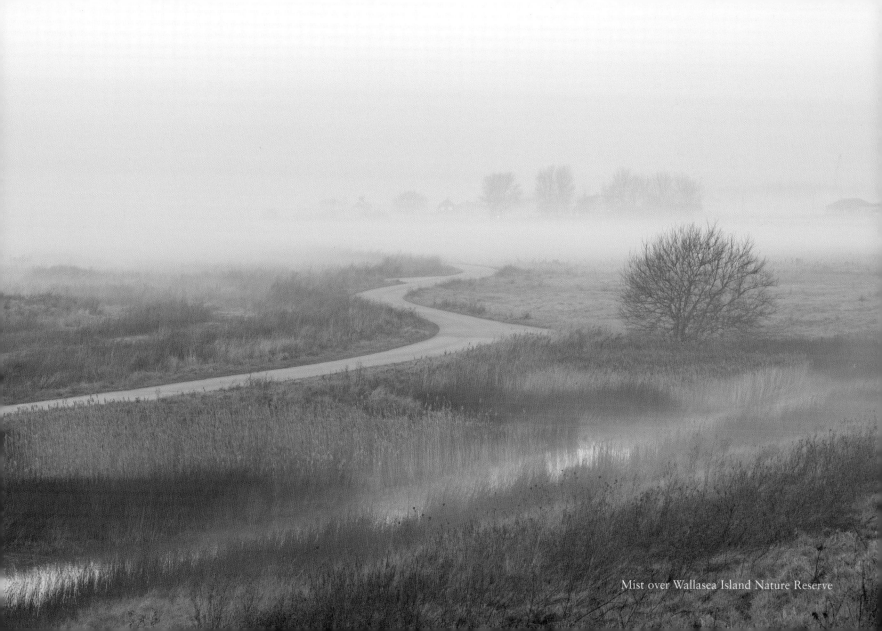

Mist over Wallasea Island Nature Reserve

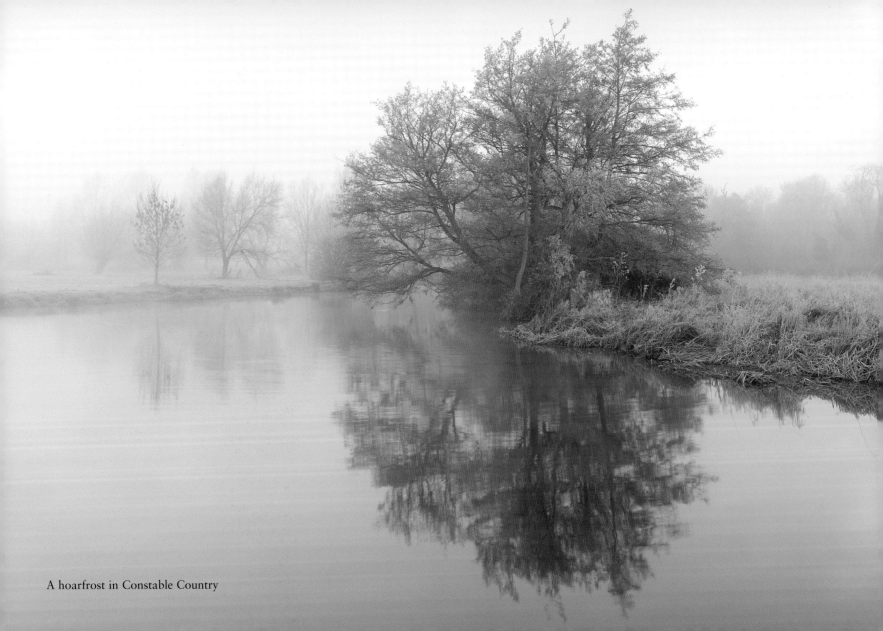
A hoarfrost in Constable Country

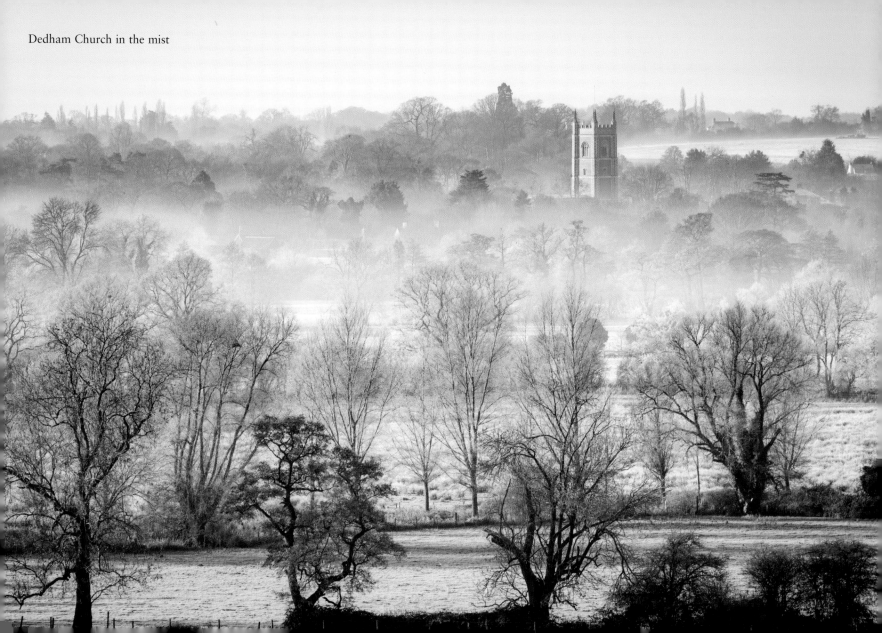

Dedham Church in the mist

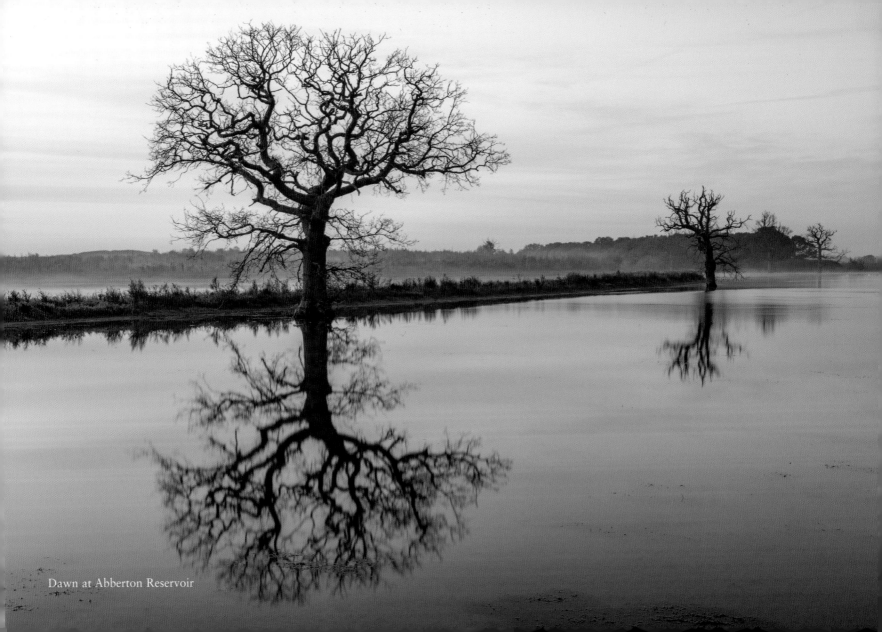

Dawn at Abberton Reservoir

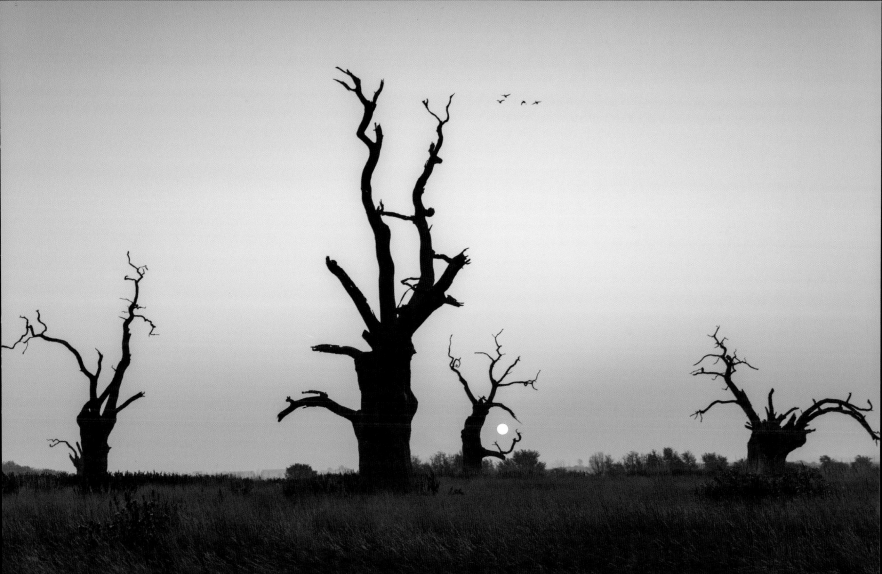

Ancient oak trees, Mundon

SALT MARSH AND ESTUARY

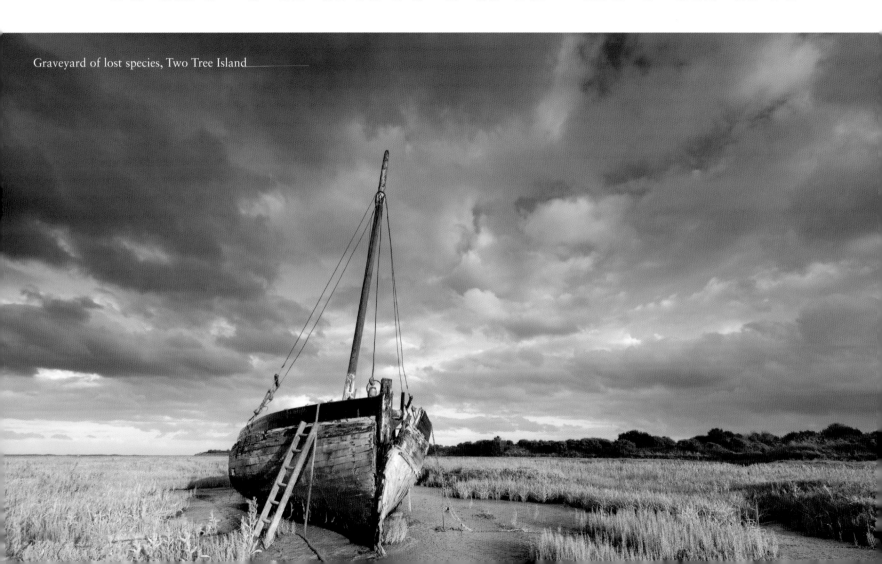

Graveyard of lost species, Two Tree Island

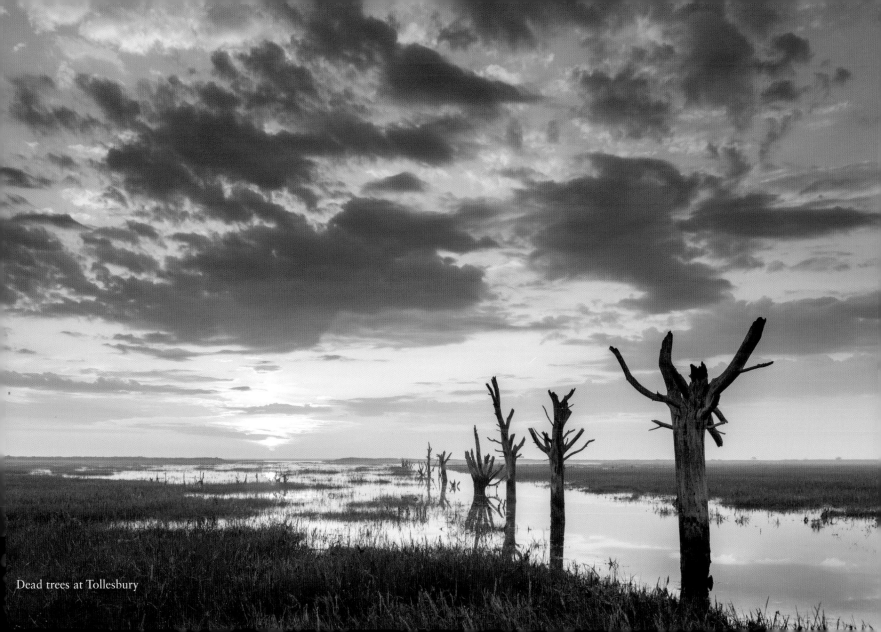

Dead trees at Tollesbury

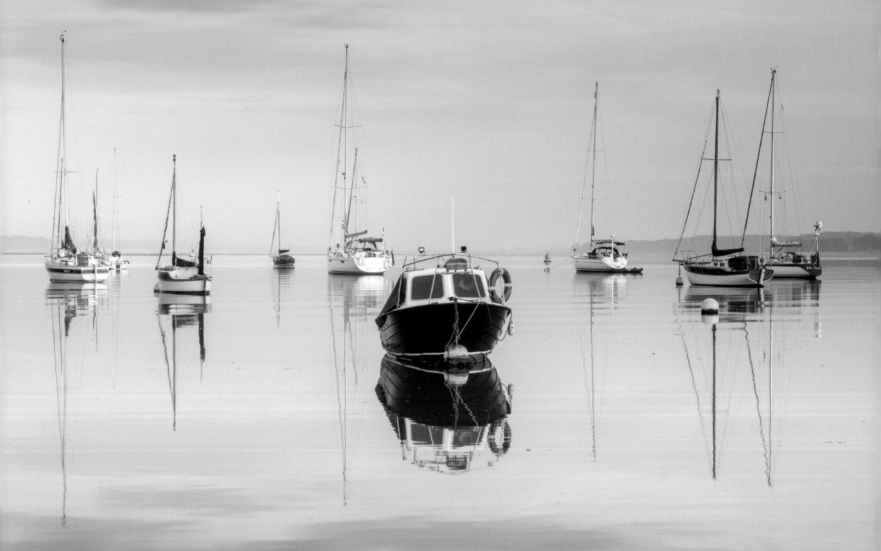

A calm River Stour at Wrabness

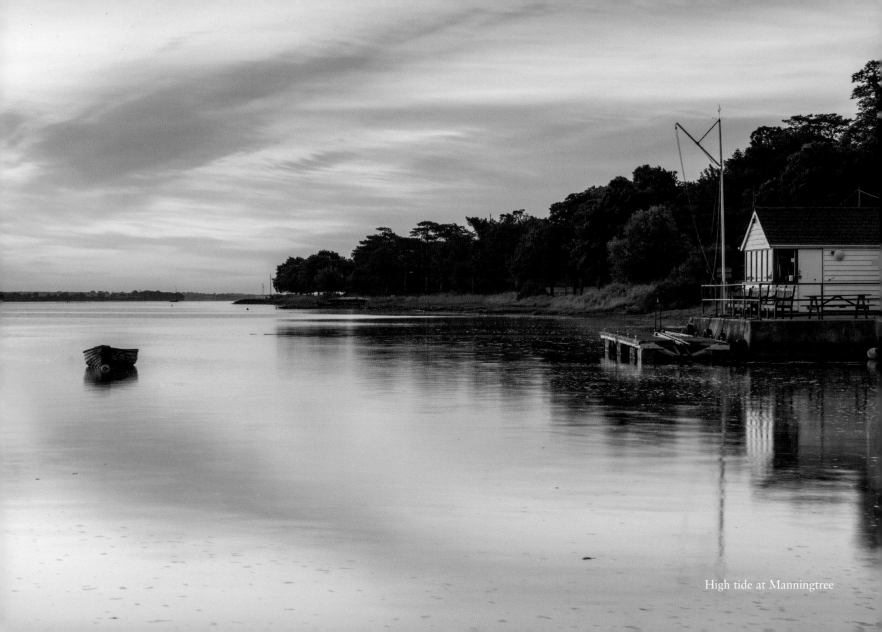

High tide at Manningtree

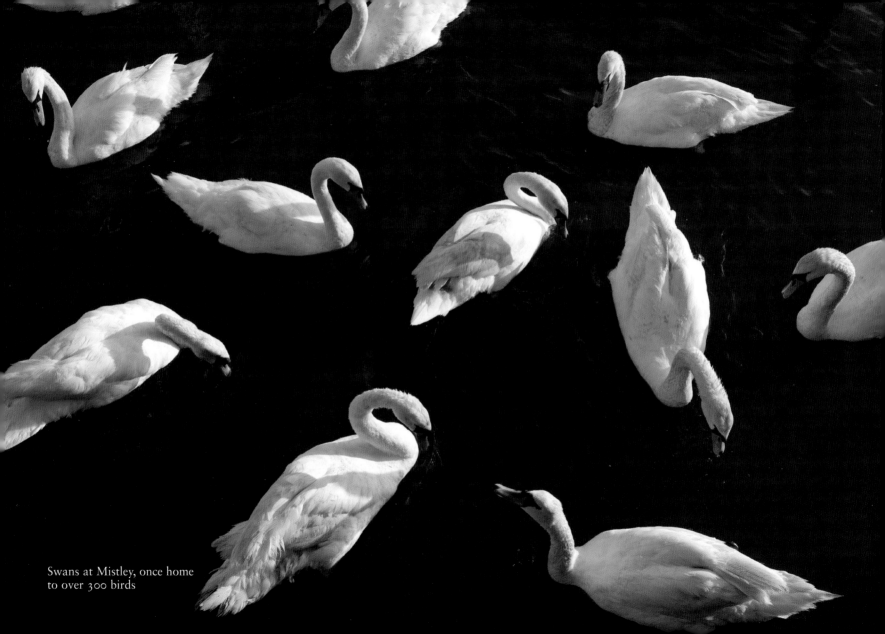

Swans at Mistley, once home to over 300 birds

Calm morning on the River Stour, Mistley

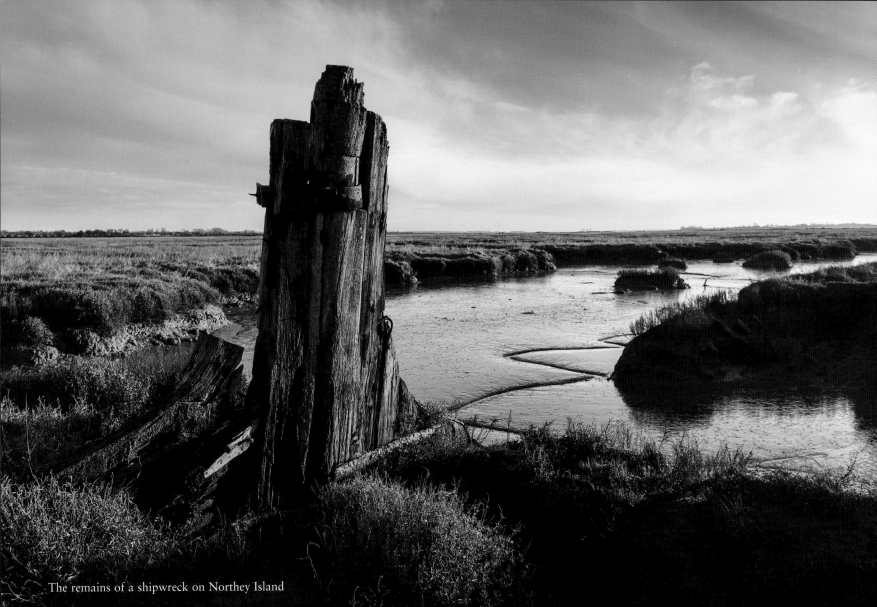

The remains of a shipwreck on Northey Island

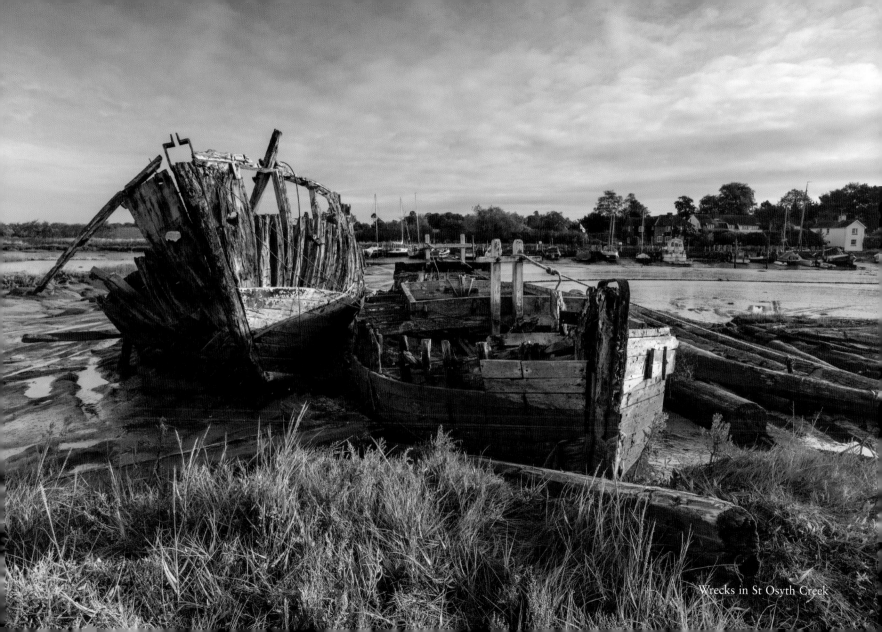

Wrecks in St Osyth Creek

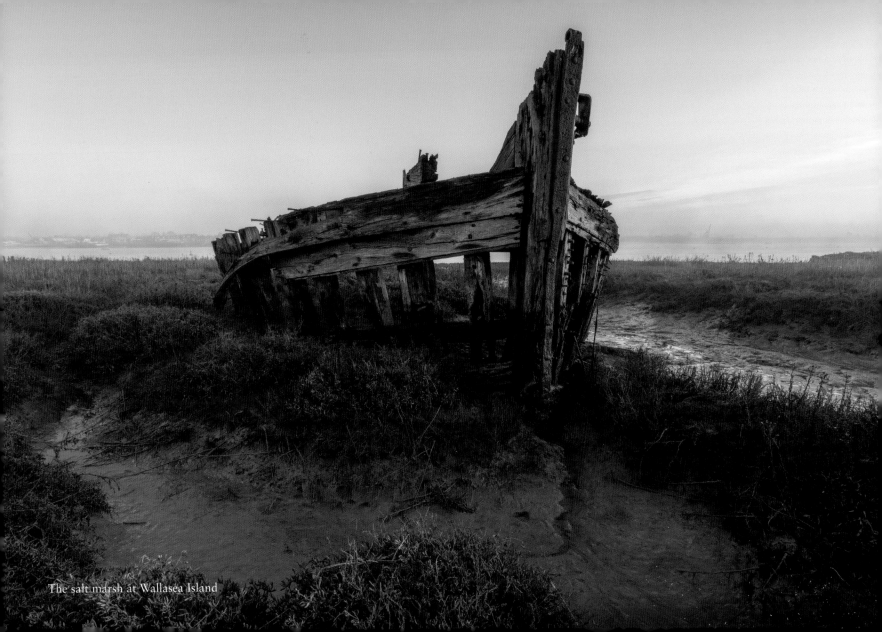

The salt marsh at Wallasea Island

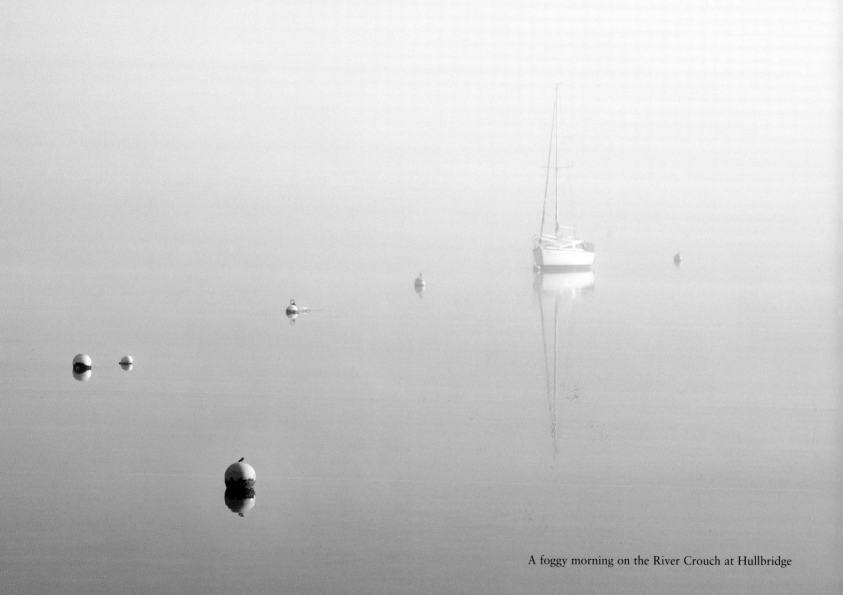

A foggy morning on the River Crouch at Hullbridge

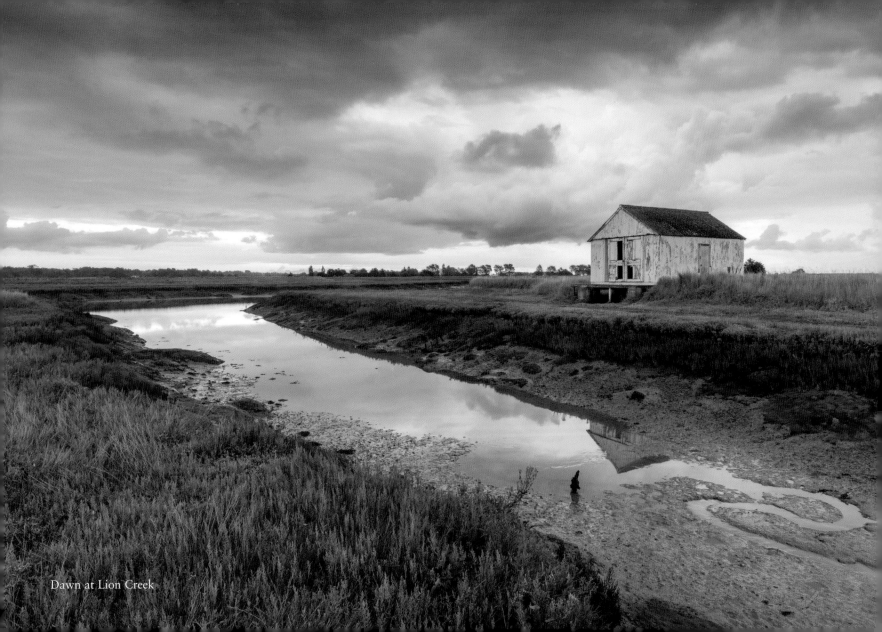

Dawn at Lion Creek

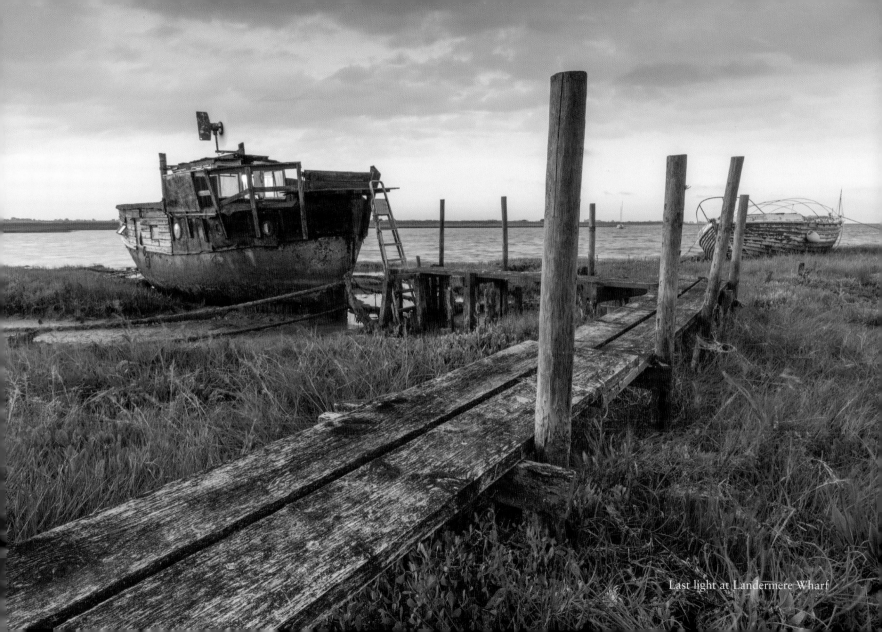

Last light at Landermere Wharf

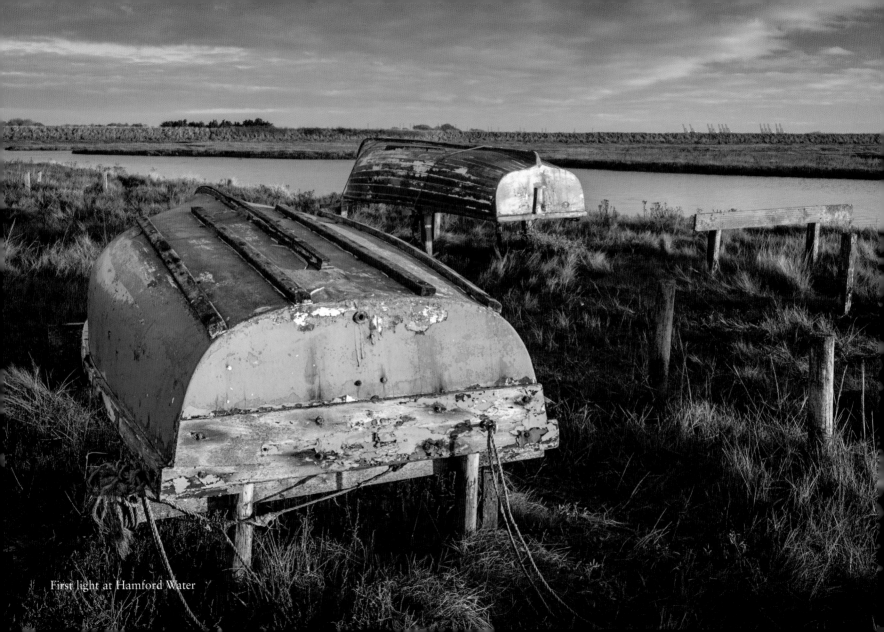

First light at Hamford Water

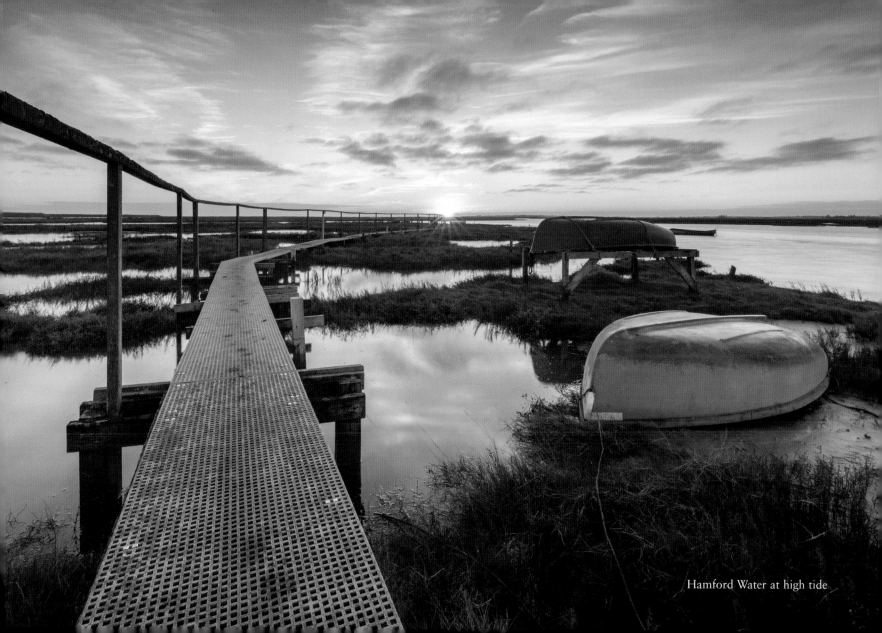

Hamford Water at high tide

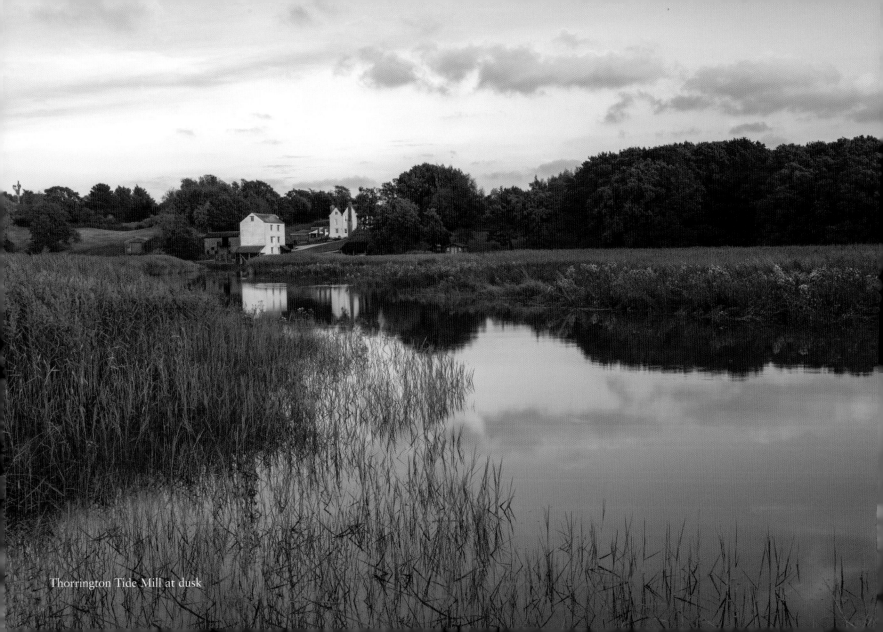

Thorrington Tide Mill at dusk

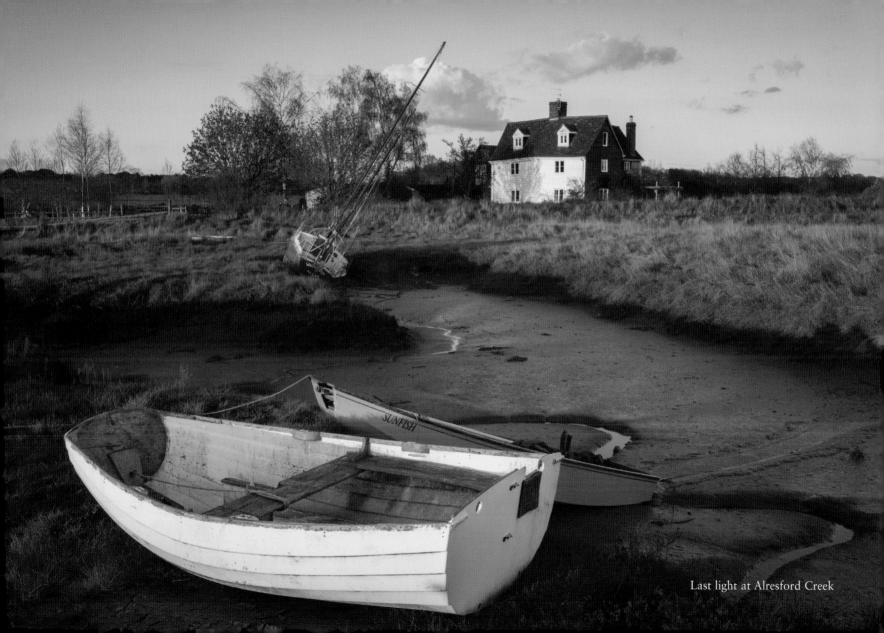

Last light at Alresford Creek

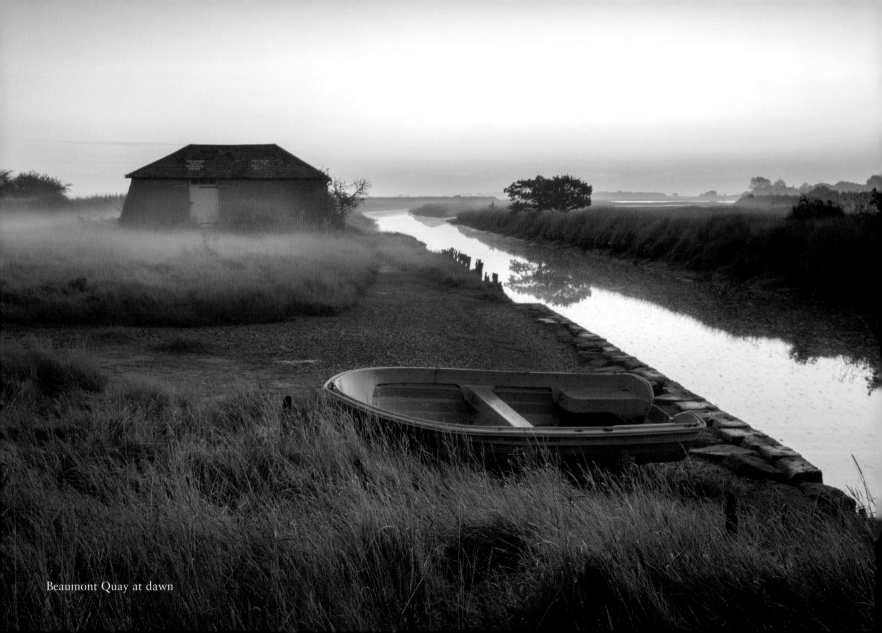

Beaumont Quay at dawn

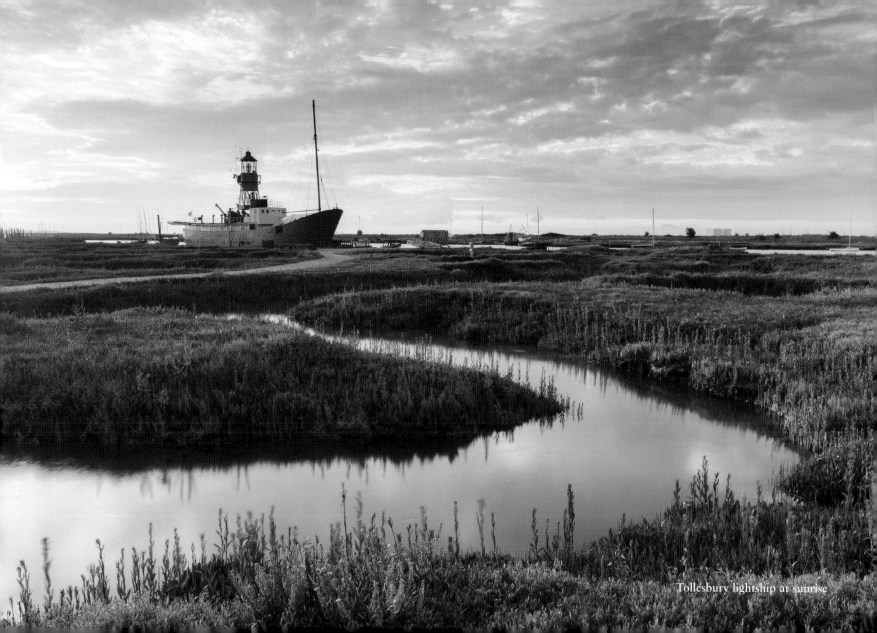

Tollesbury lightship at sunrise

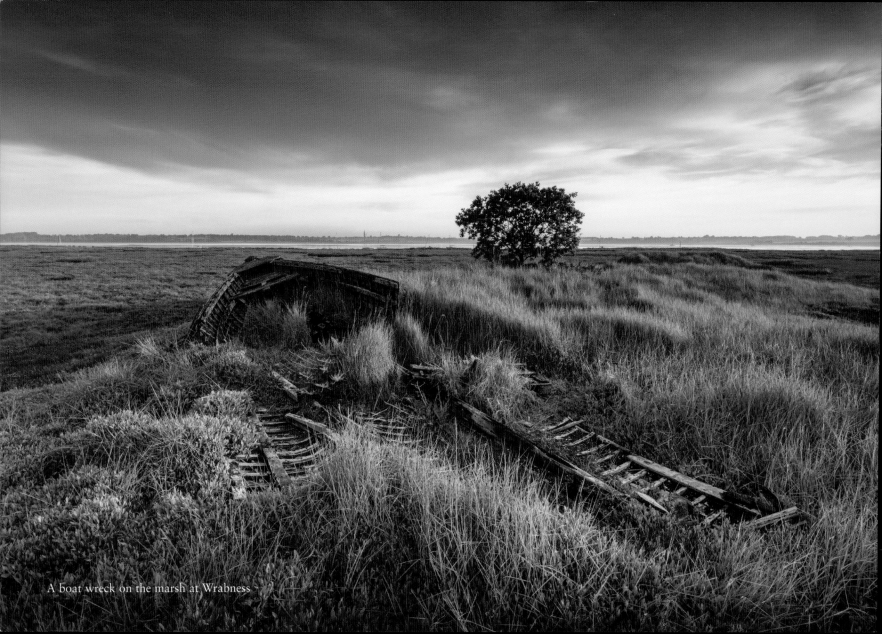

A boat wreck on the marsh at Wrabness

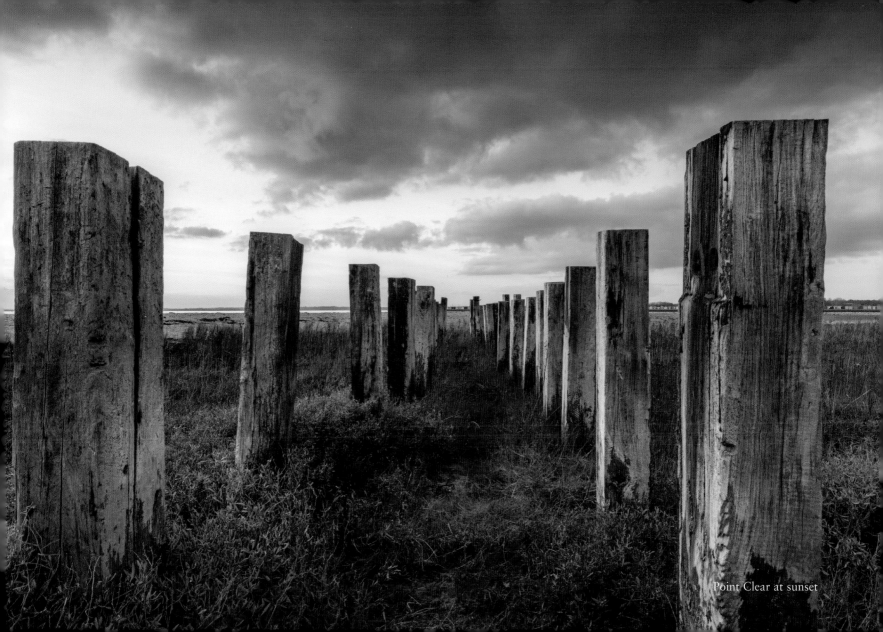

Point Clear at sunset

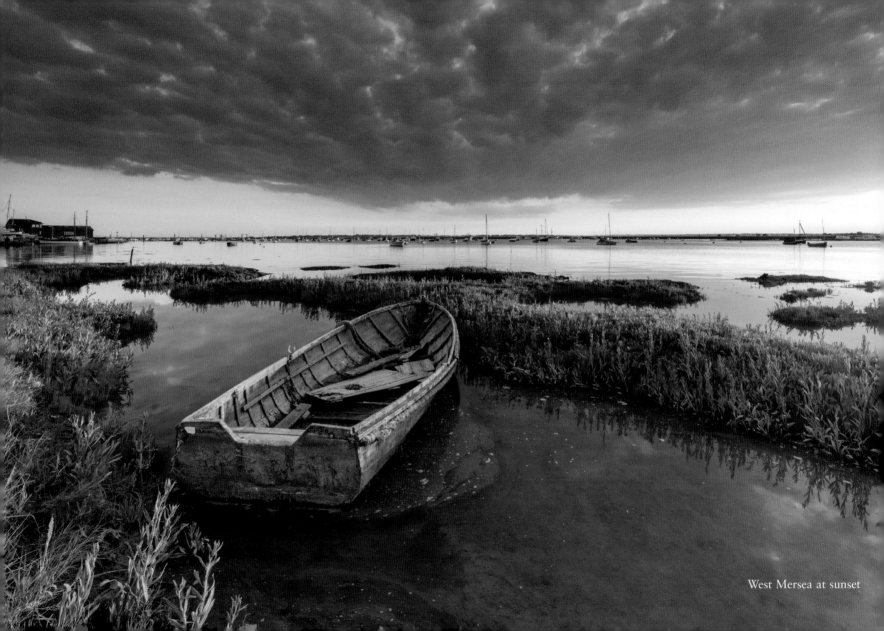

West Mersea at sunset

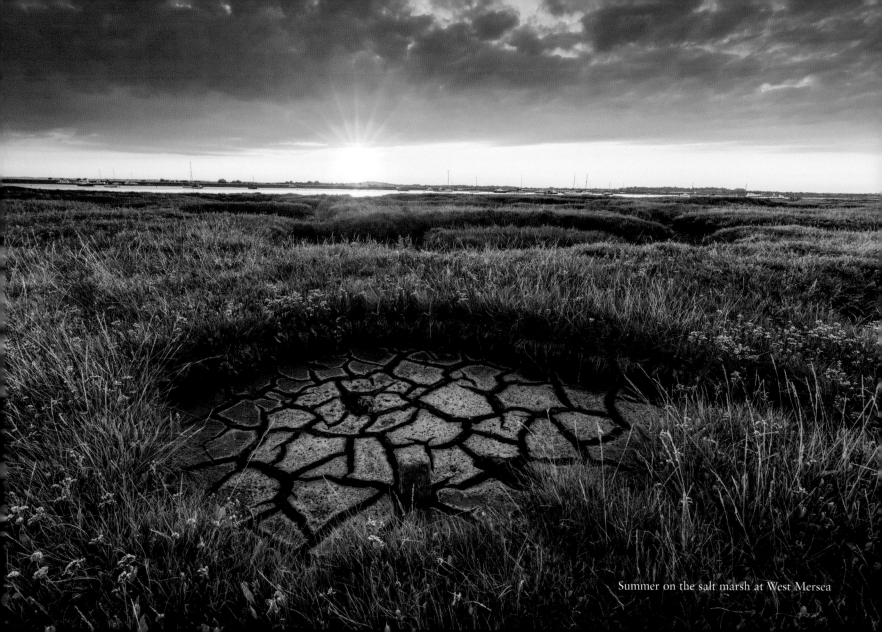

Summer on the salt marsh at West Mersea

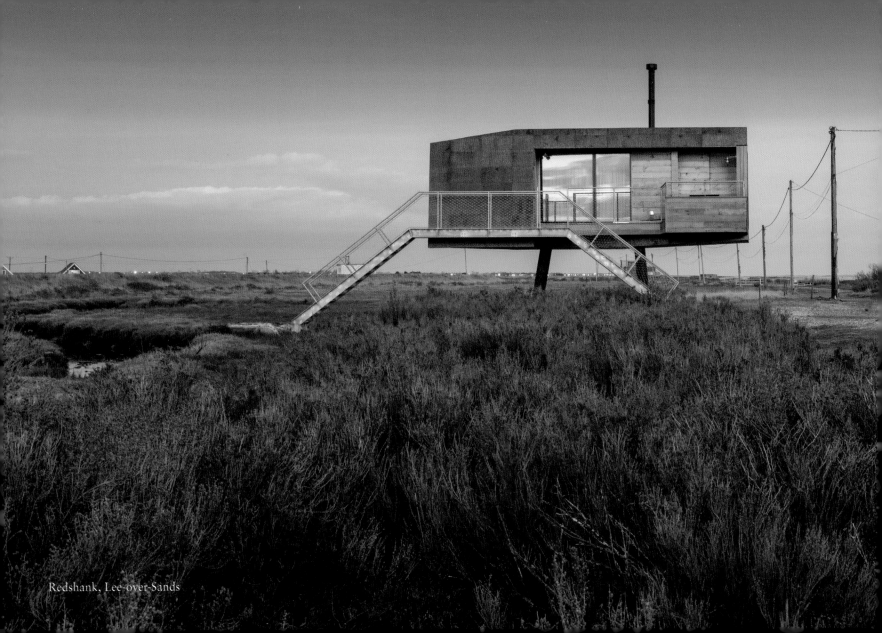

Redshank, Lee-over-Sands

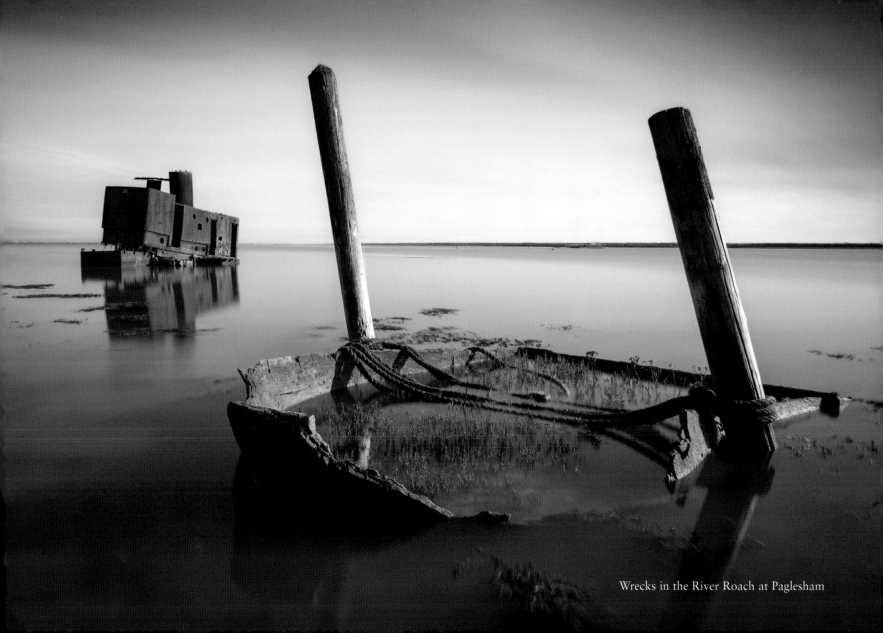

Wrecks in the River Roach at Paglesham

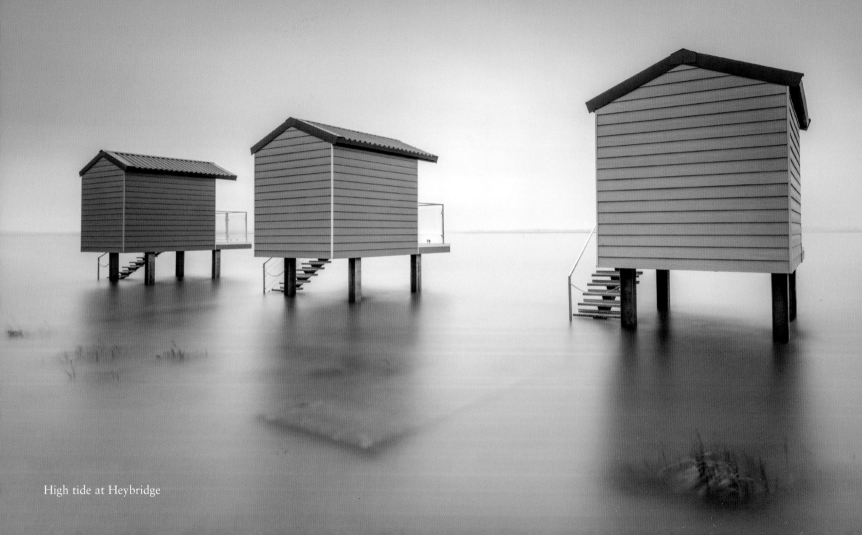

High tide at Heybridge

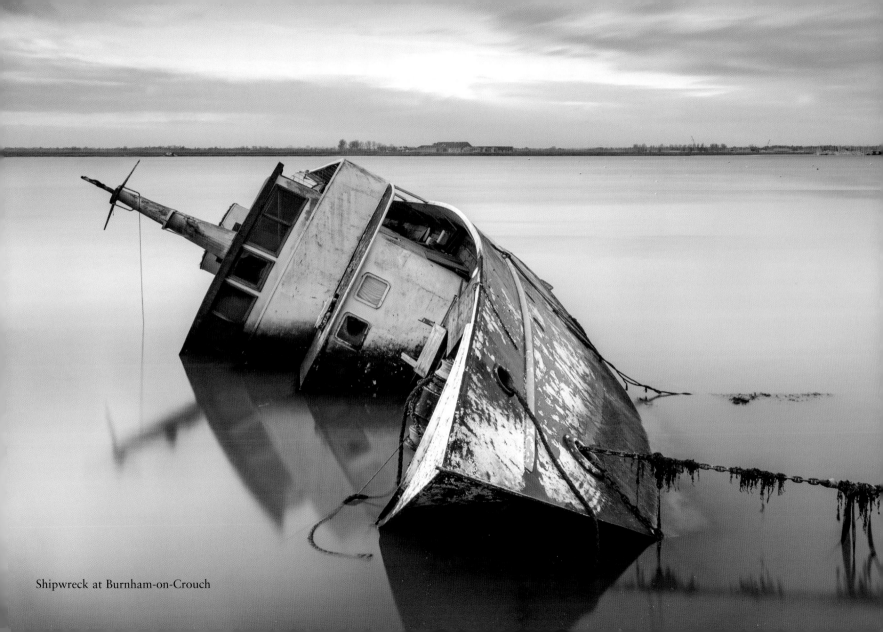
Shipwreck at Burnham-on-Crouch

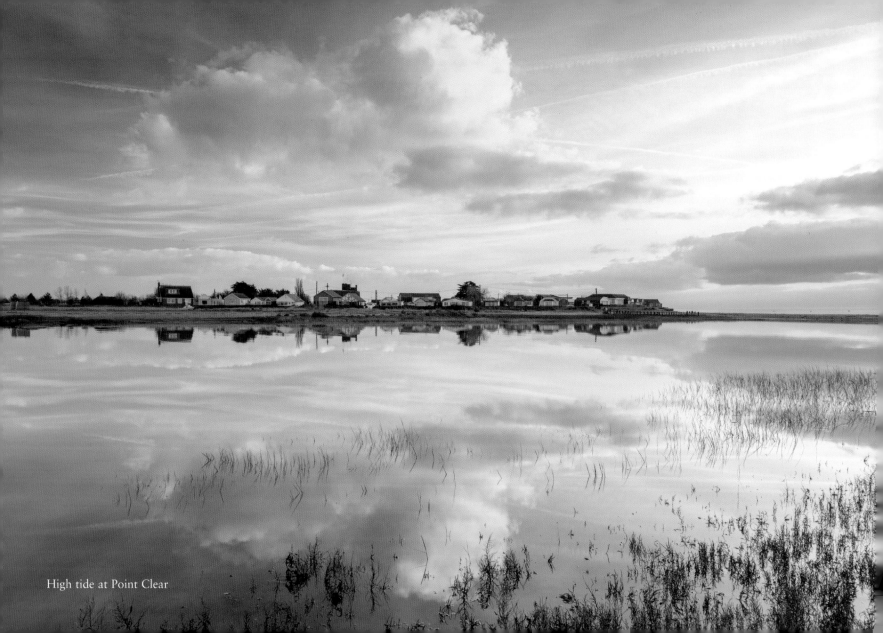

High tide at Point Clear

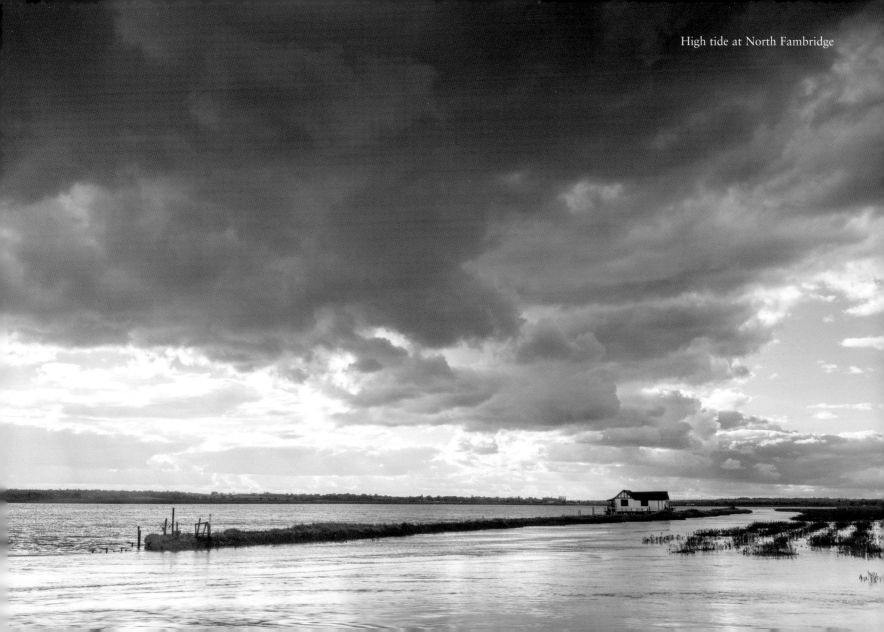

High tide at North Fambridge

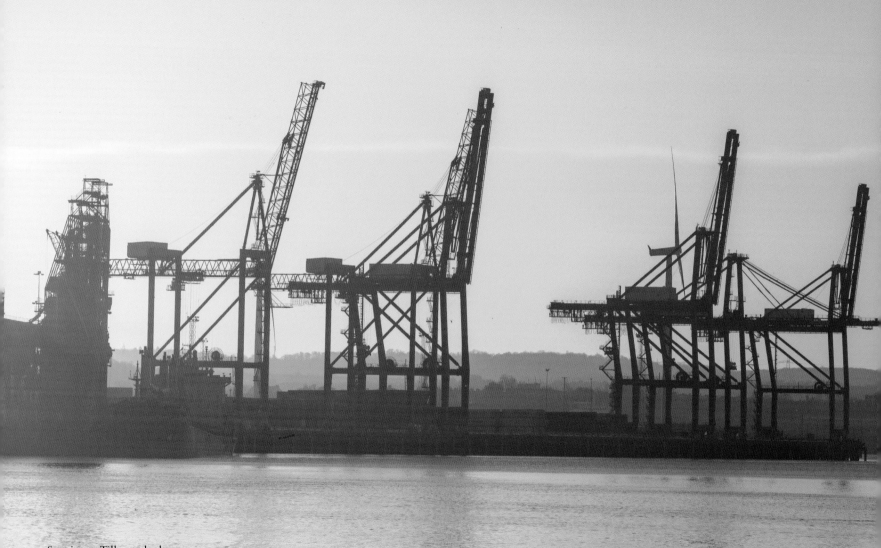

Sunrise at Tilbury docks

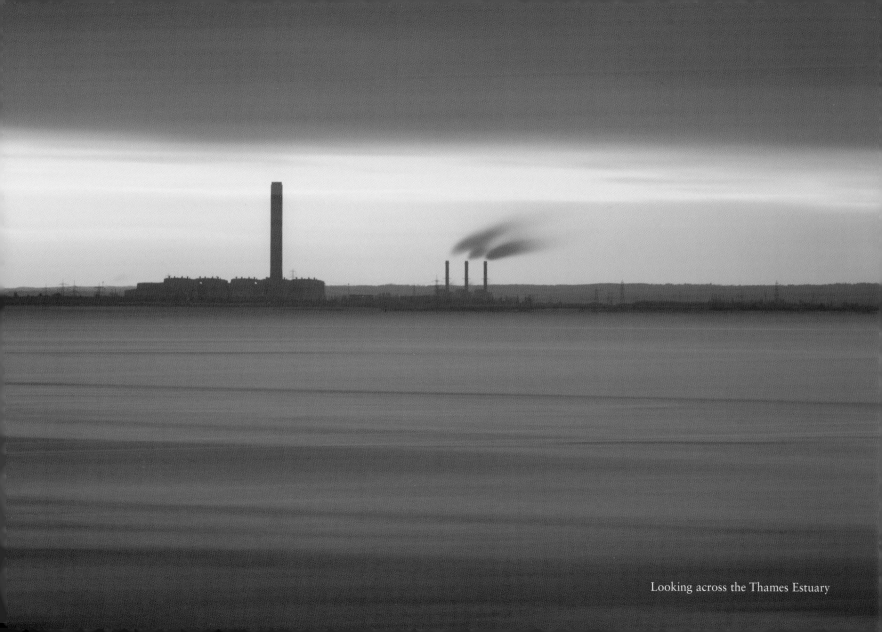
Looking across the Thames Estuary

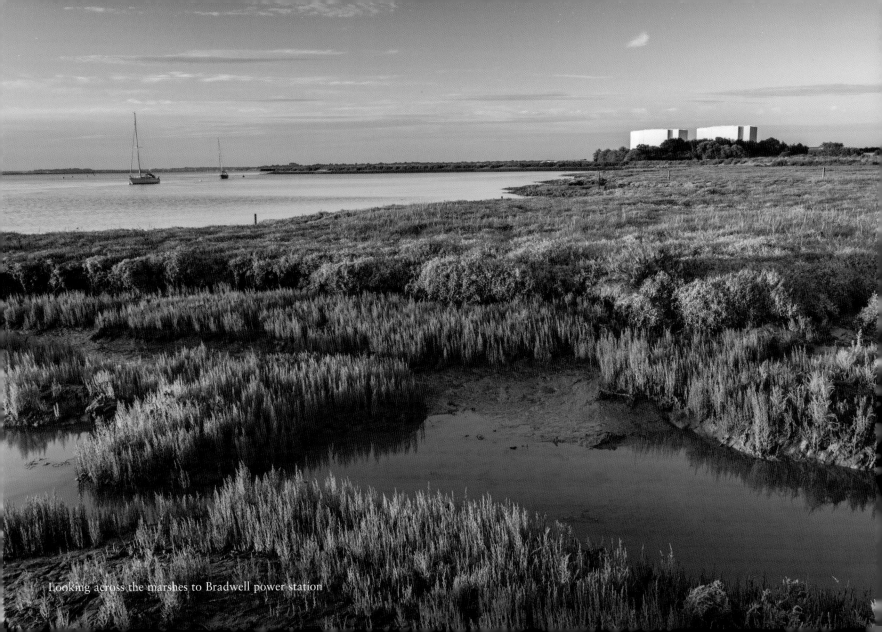

Looking across the marshes to Bradwell power station

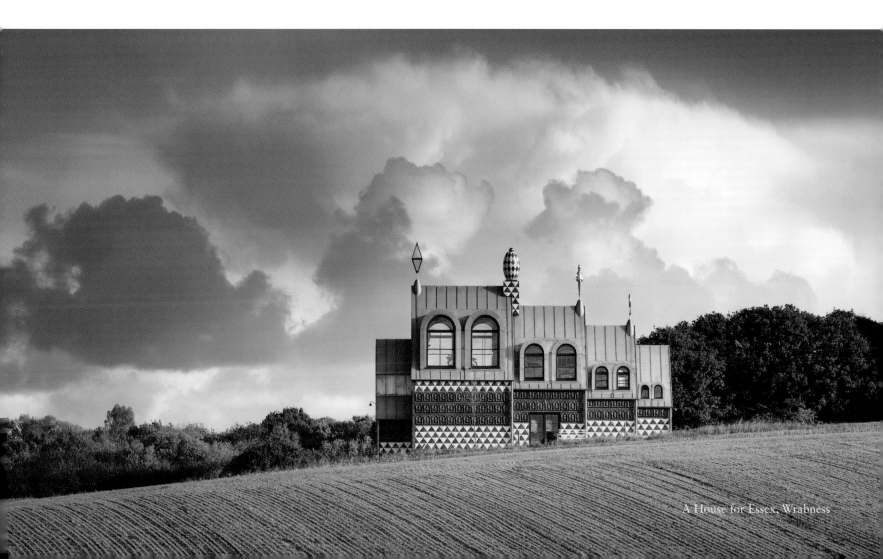

A House for Essex, Wrabness

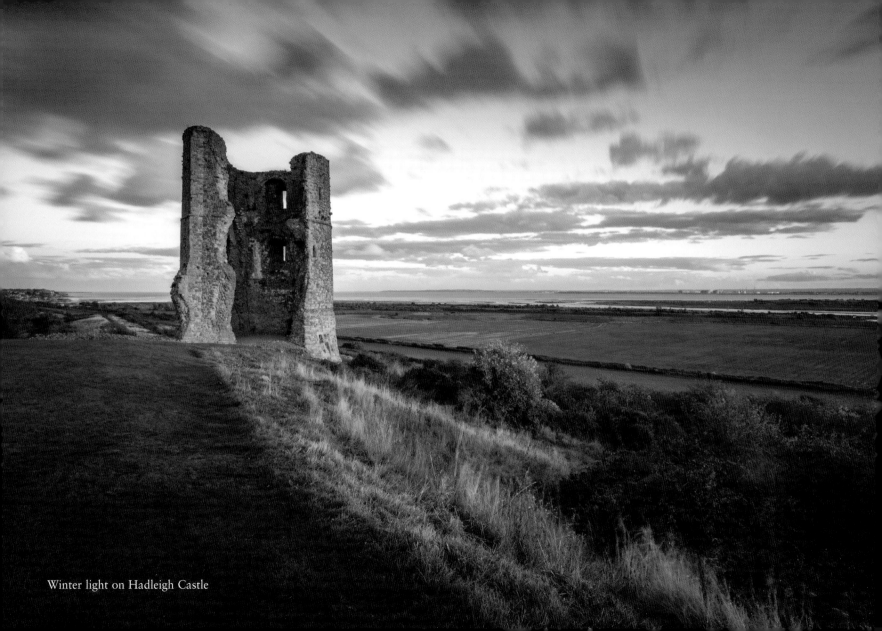

Winter light on Hadleigh Castle

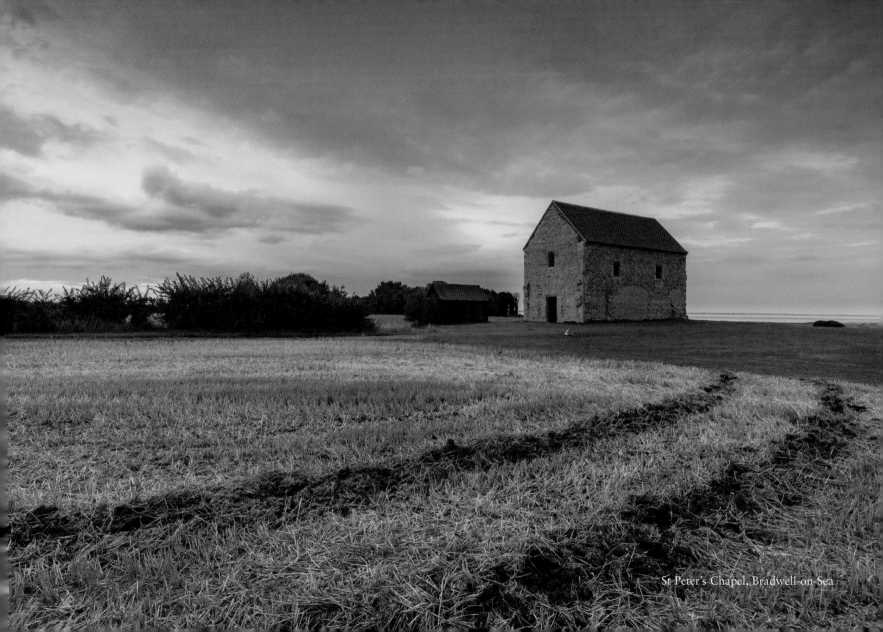

St Peter's Chapel, Bradwell-on-Sea

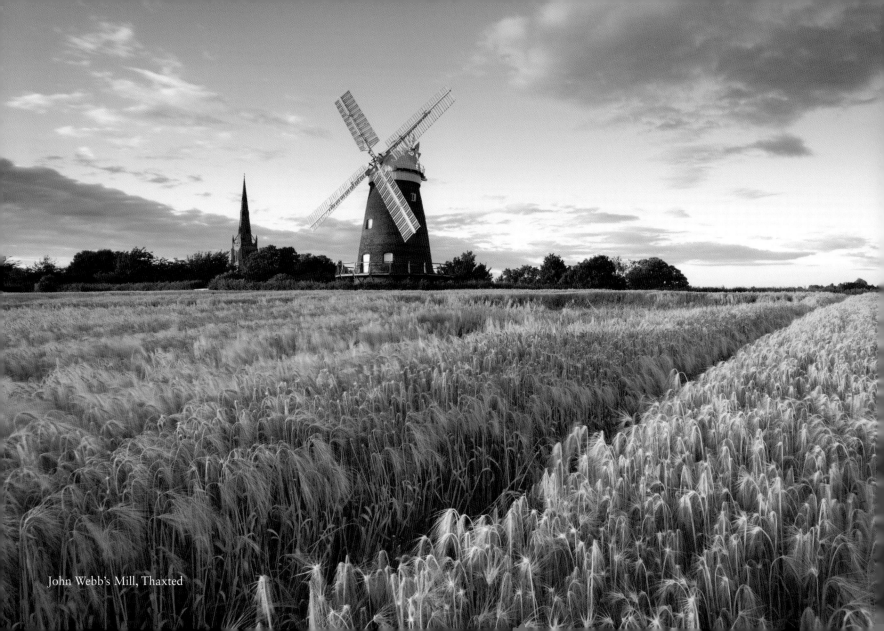

John Webb's Mill, Thaxted

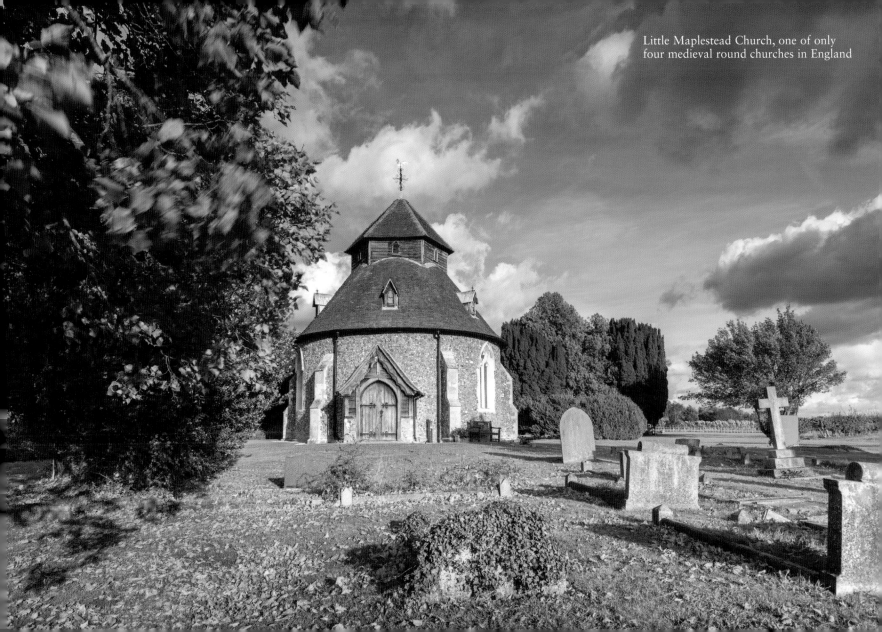

Little Maplestead Church, one of only
four medieval round churches in England

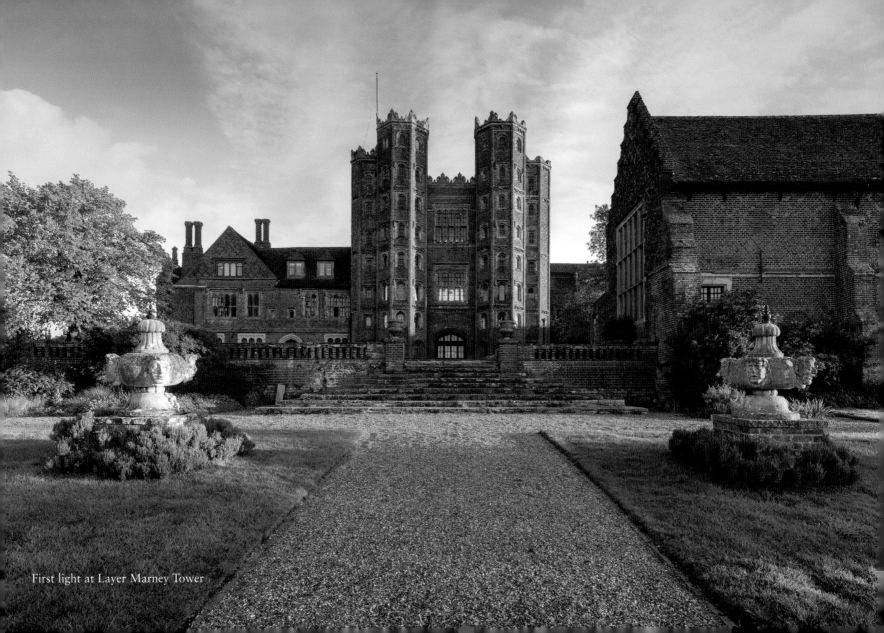

First light at Layer Marney Tower

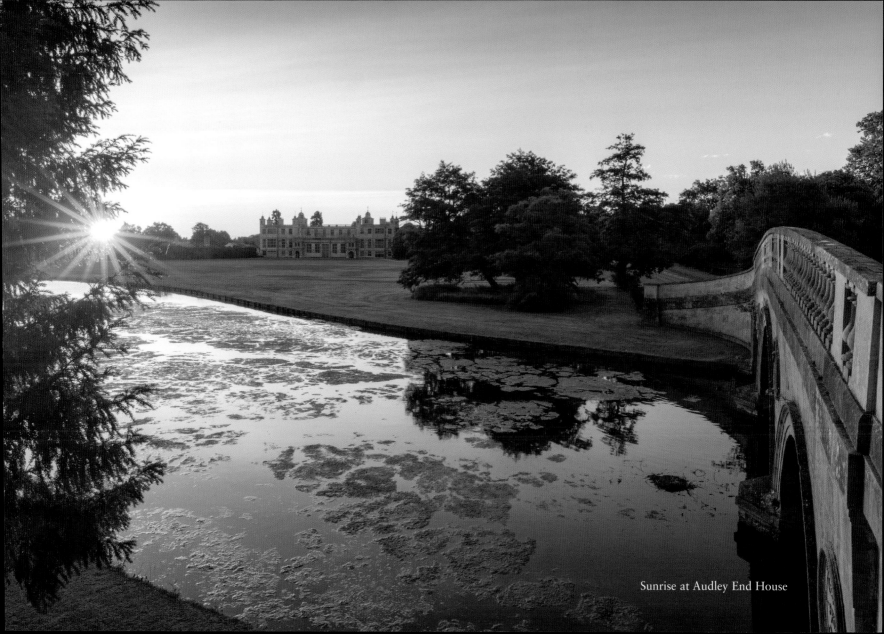

Sunrise at Audley End House

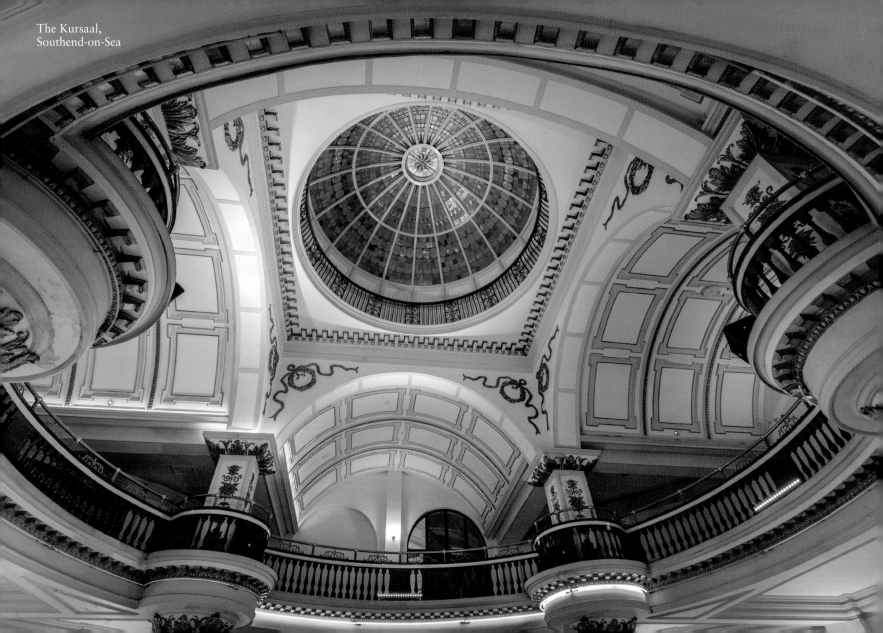
The Kursaal,
Southend-on-Sea

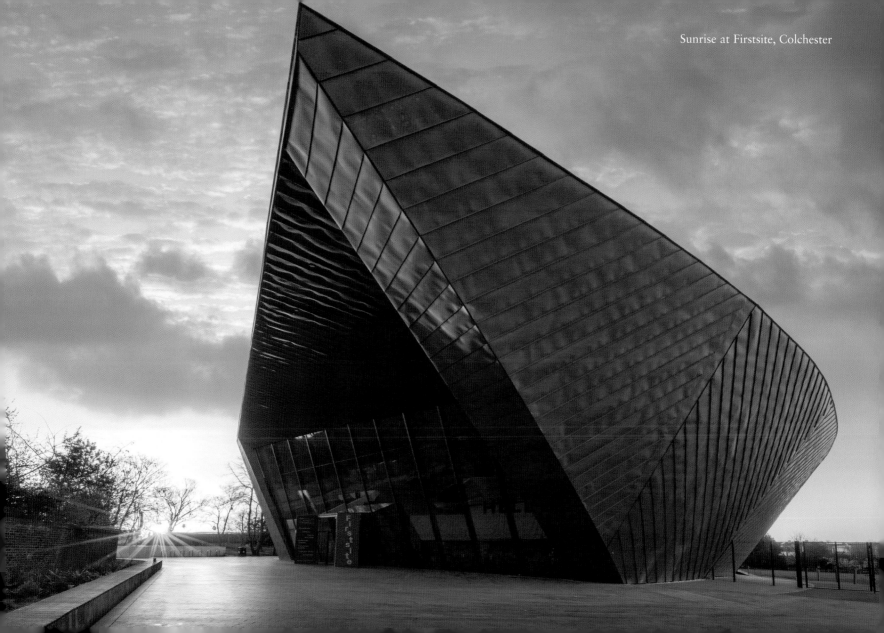

Sunrise at Firstsite, Colchester

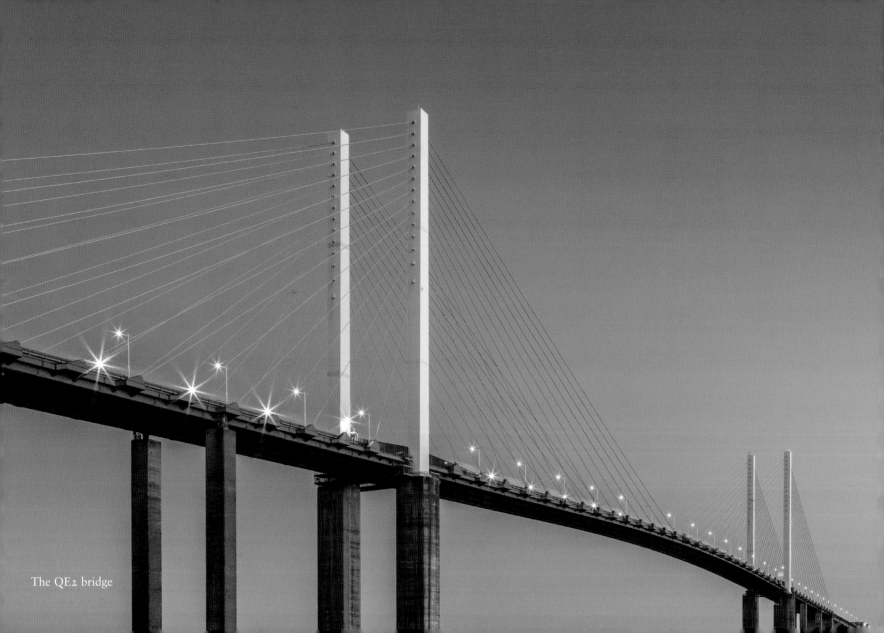

The QE2 bridge

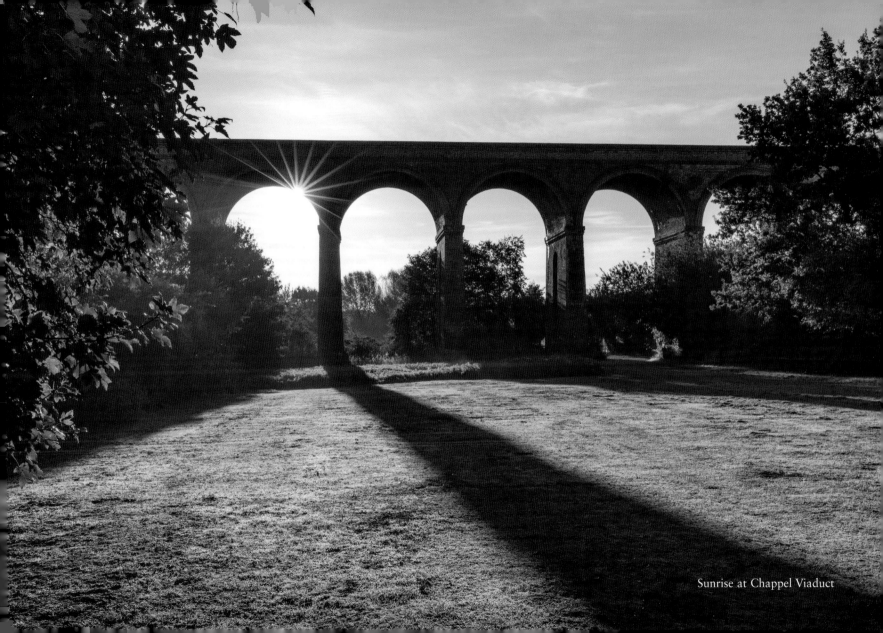

Sunrise at Chappel Viaduct

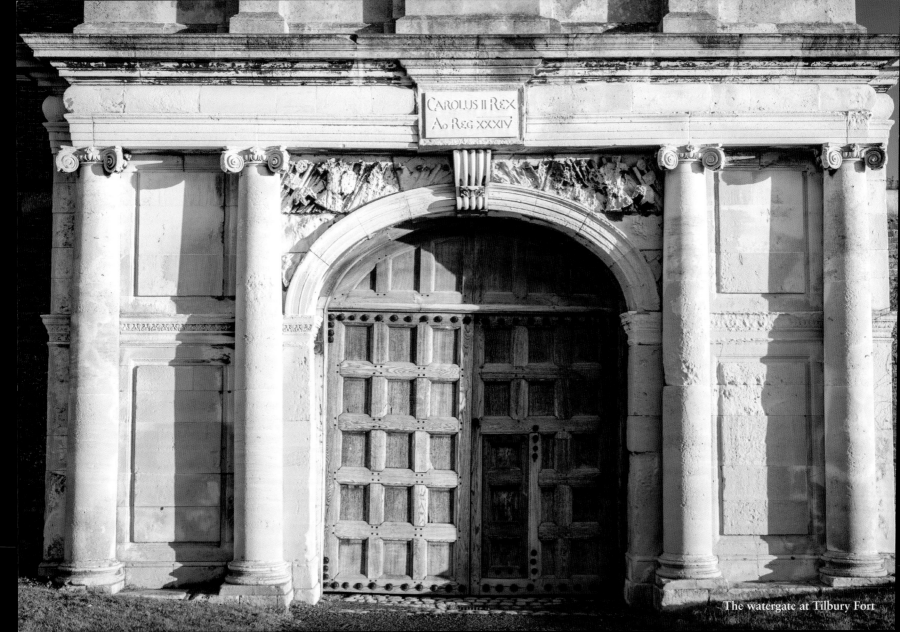

The watergate at Tilbury Fort

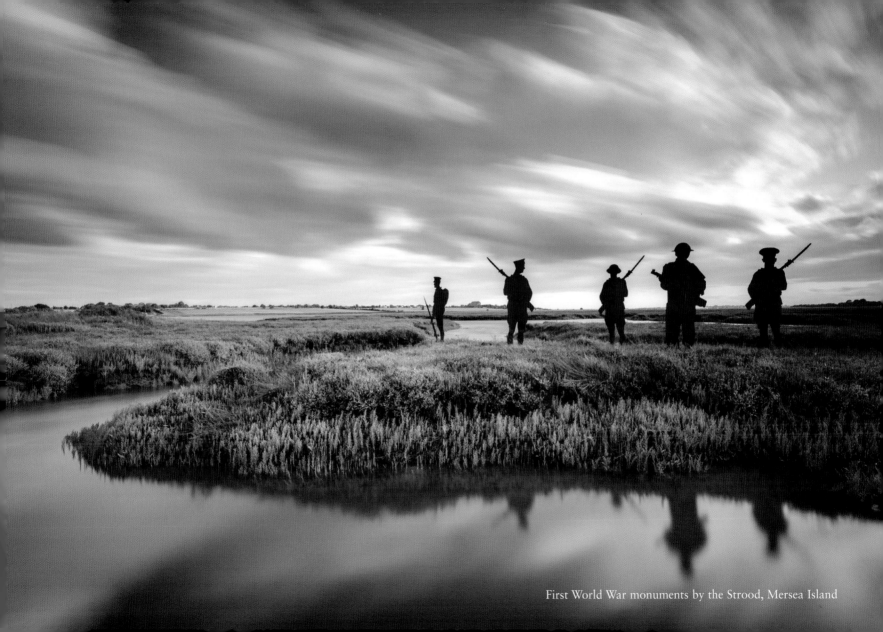

First World War monuments by the Strood, Mersea Island

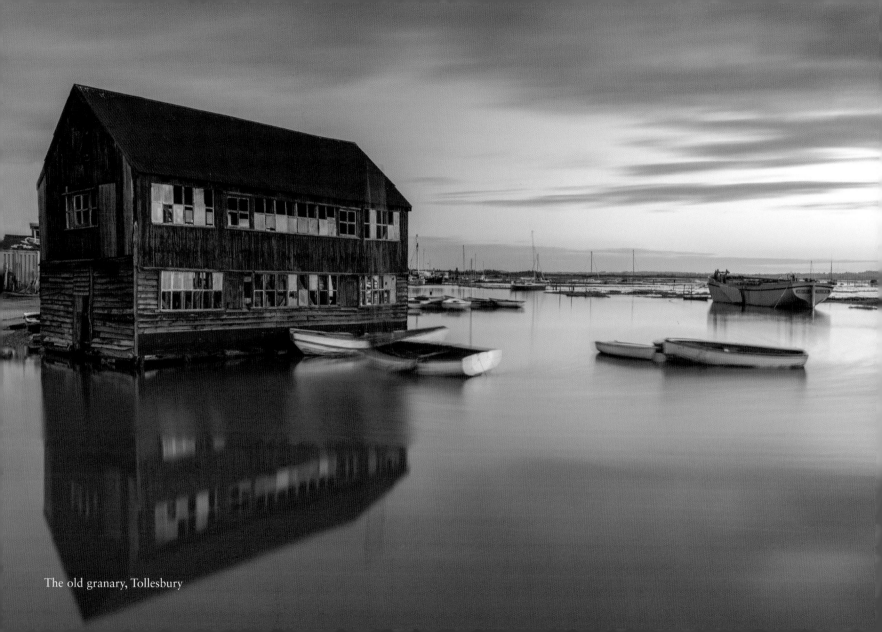

The old granary, Tollesbury

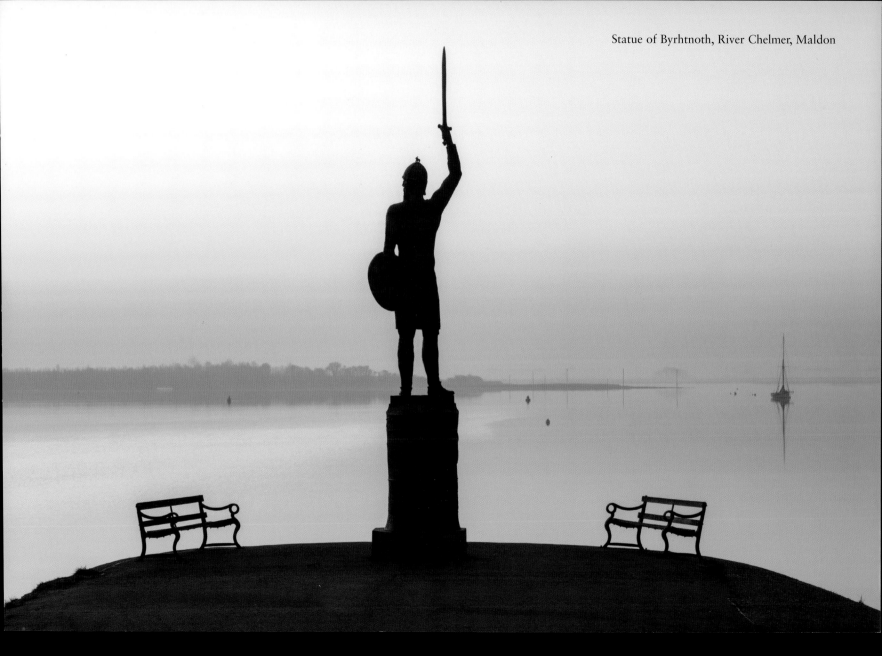

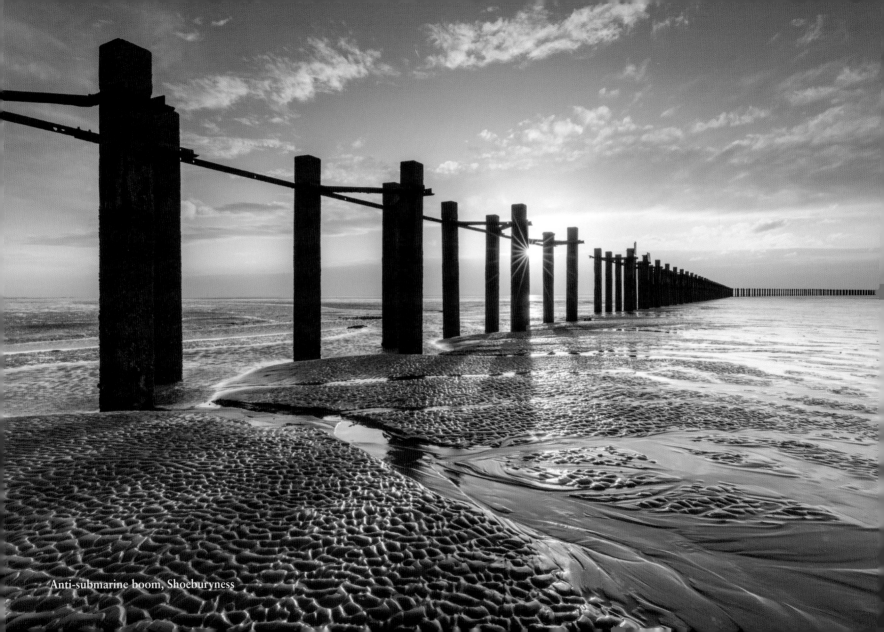
Anti-submarine boom, Shoeburyness

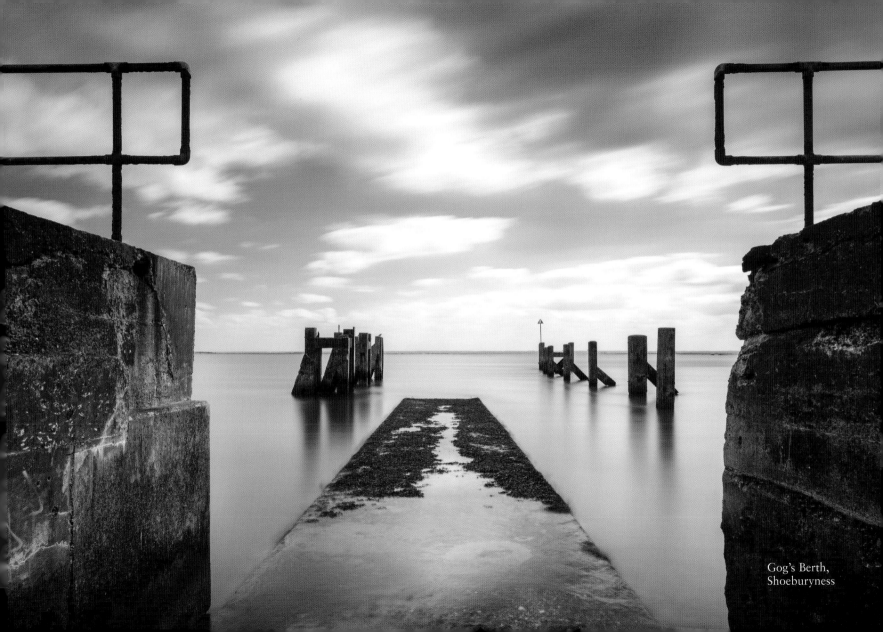

Gog's Berth,
Shoeburyness

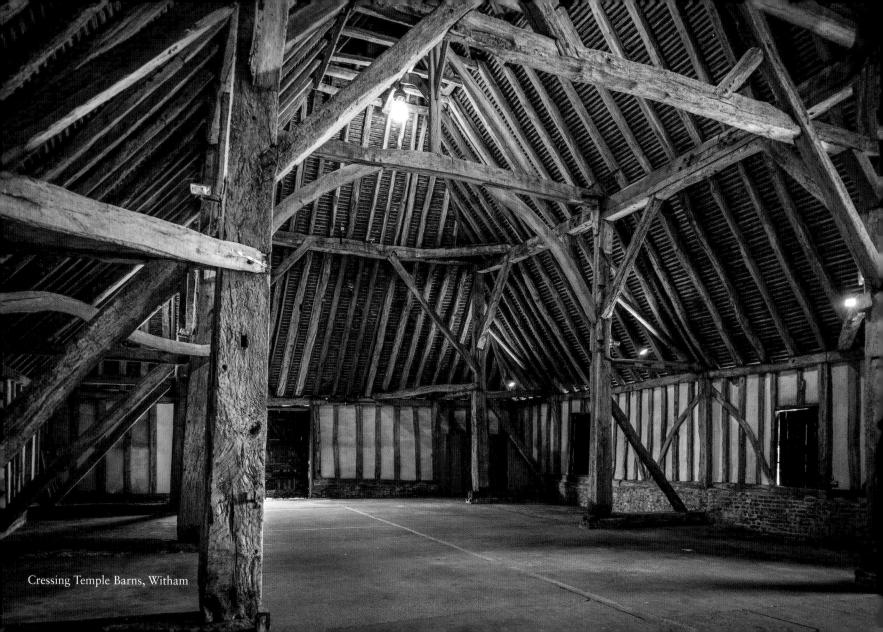

Cressing Temple Barns, Witham

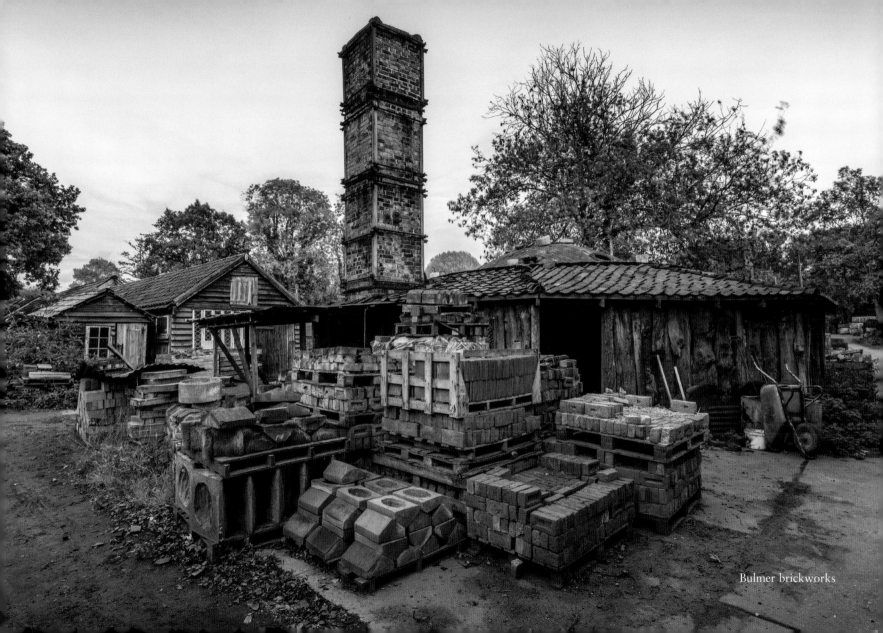

Bulmer brickworks

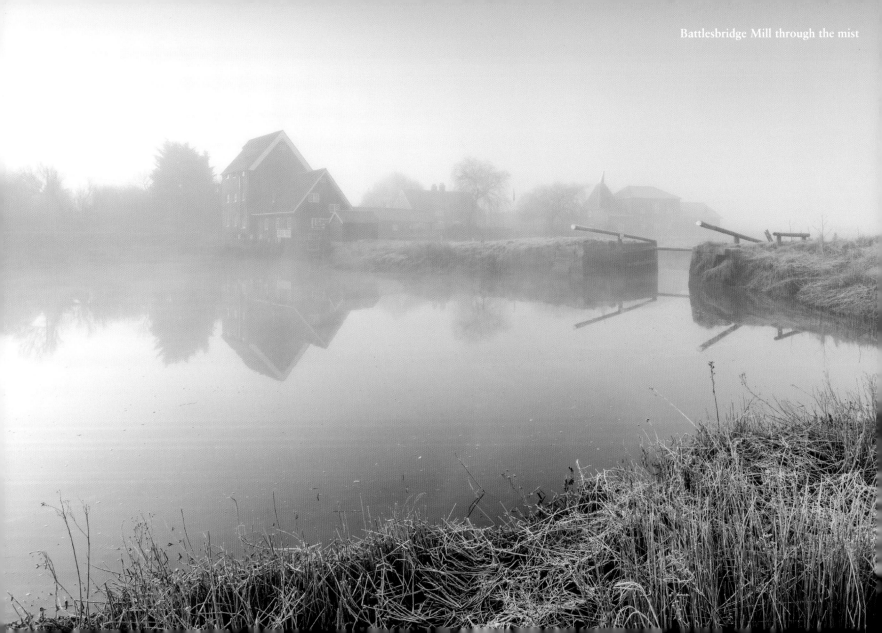

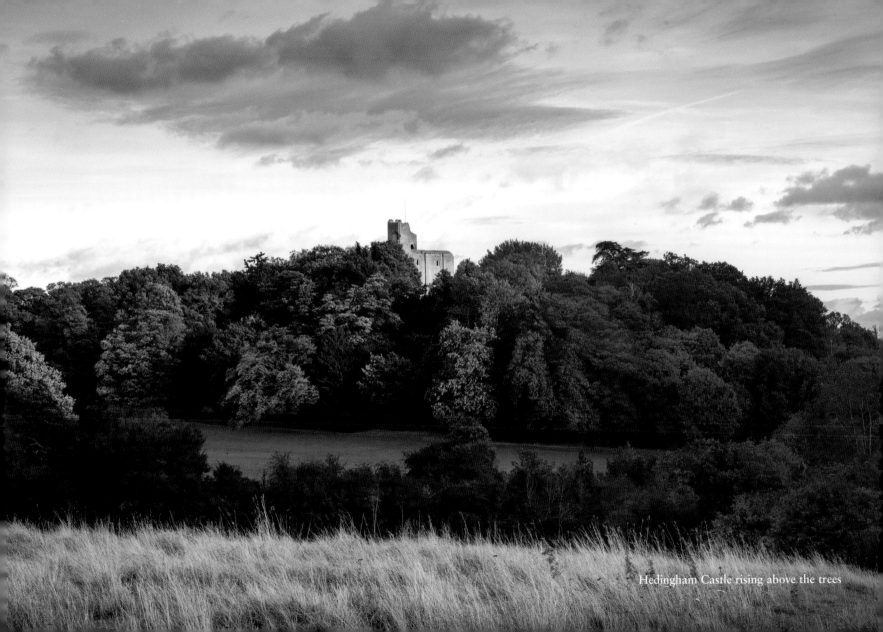

Hedingham Castle rising above the trees

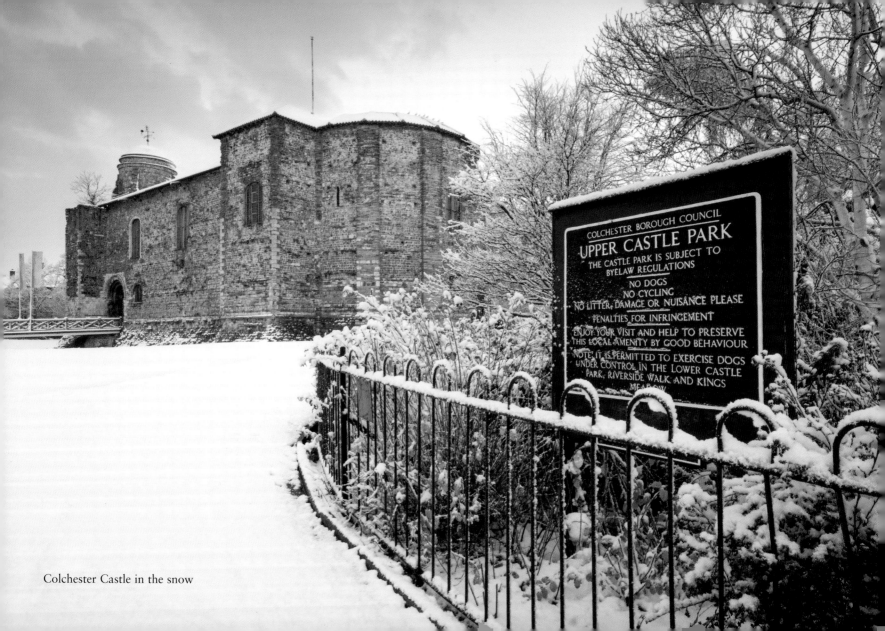

Colchester Castle in the snow

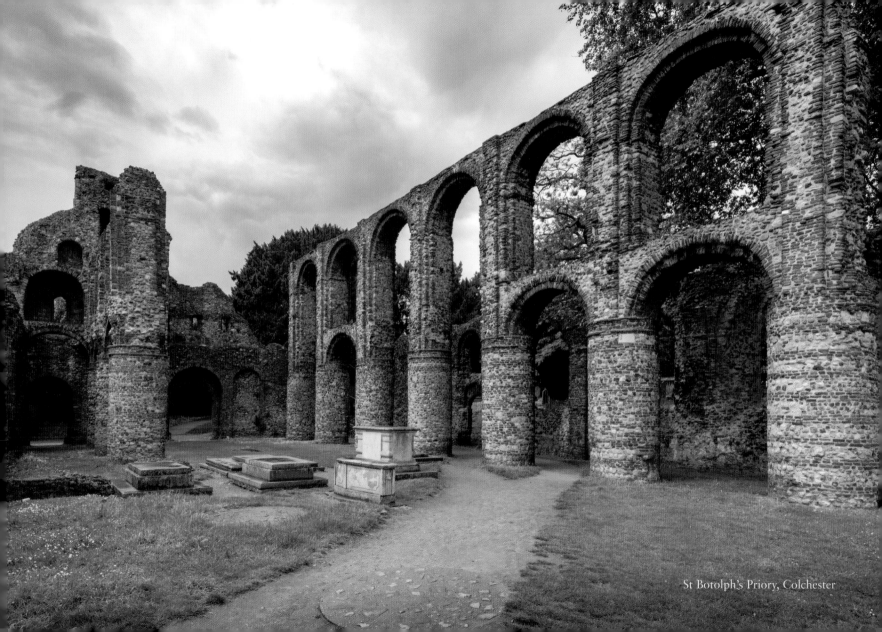

St Botolph's Priory, Colchester

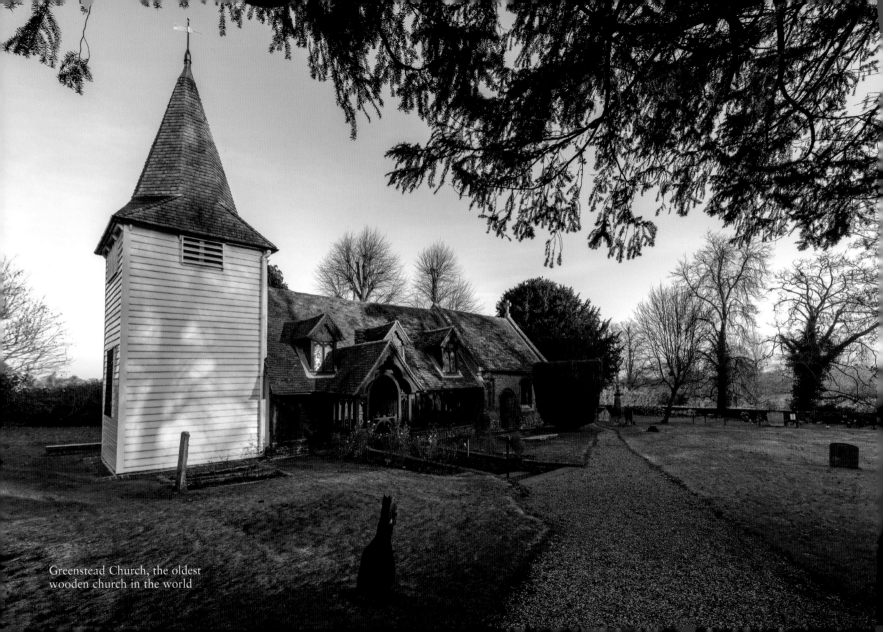

Greenstead Church, the oldest
wooden church in the world

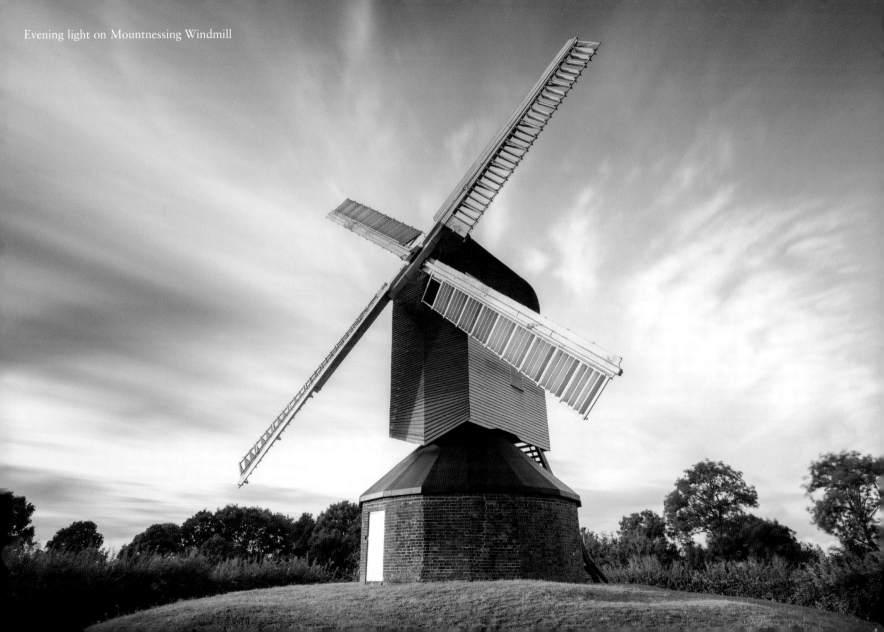

Evening light on Mountnessing Windmill

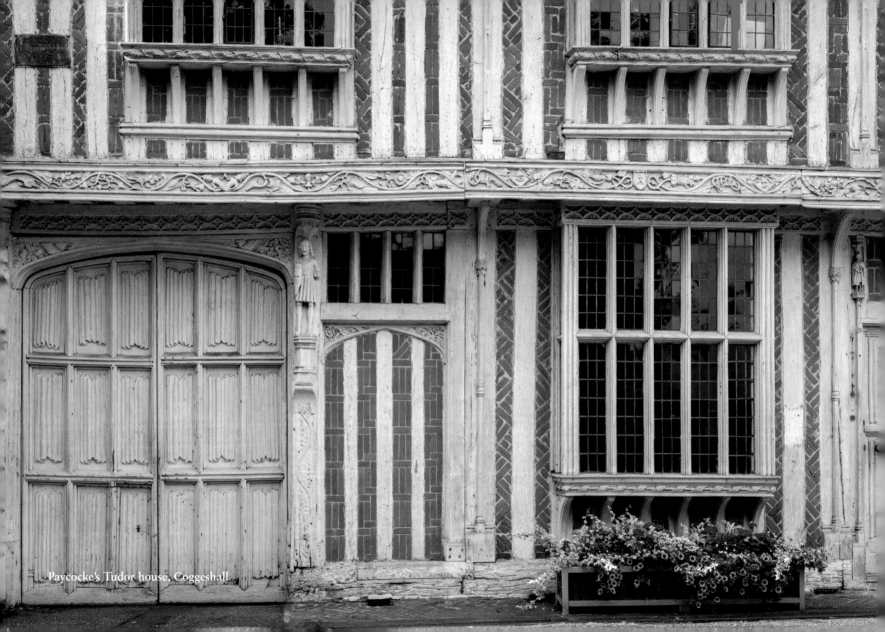

Paycocke's Tudor house, Coggeshall

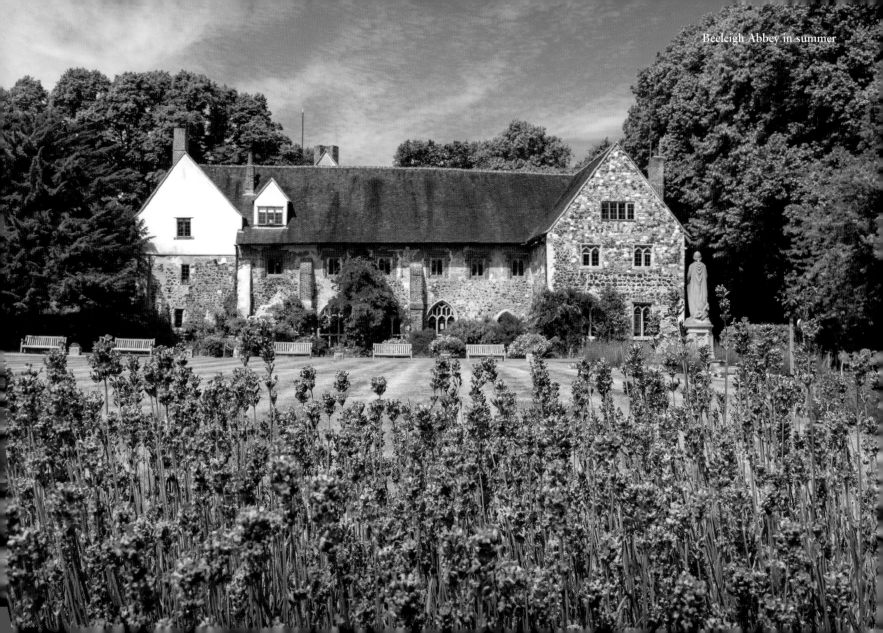
Beeleigh Abbey in summer

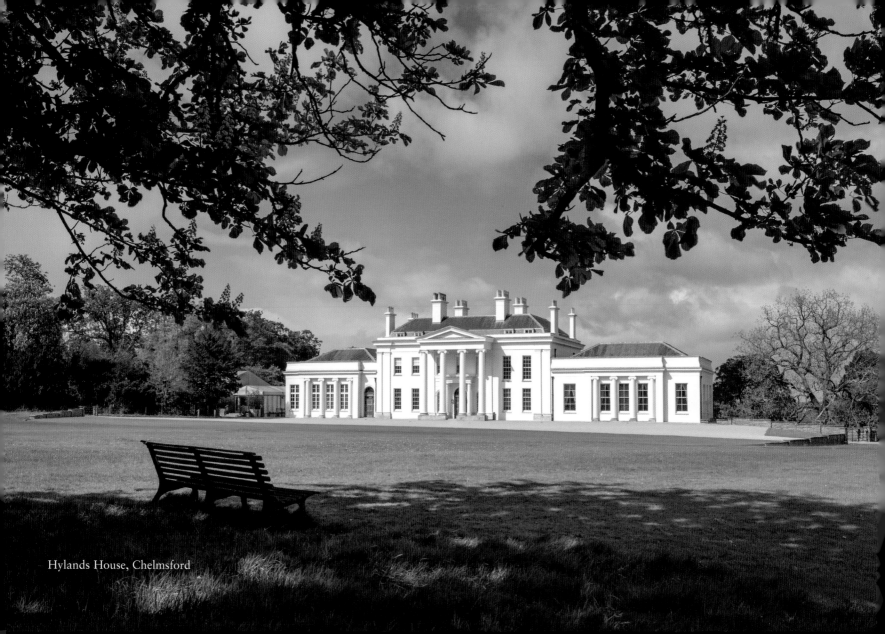

Hylands House, Chelmsford

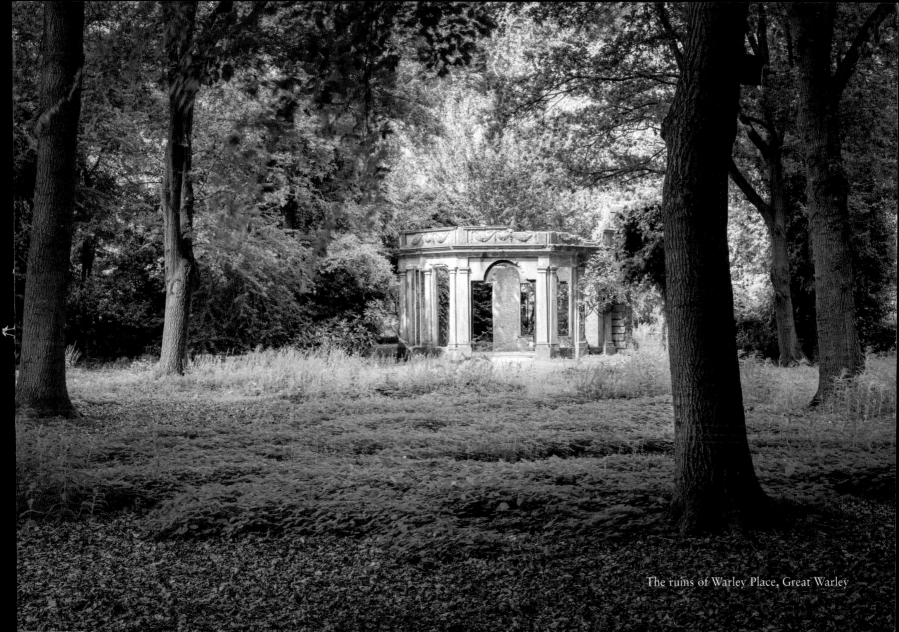

The ruins of Warley Place, Great Warley

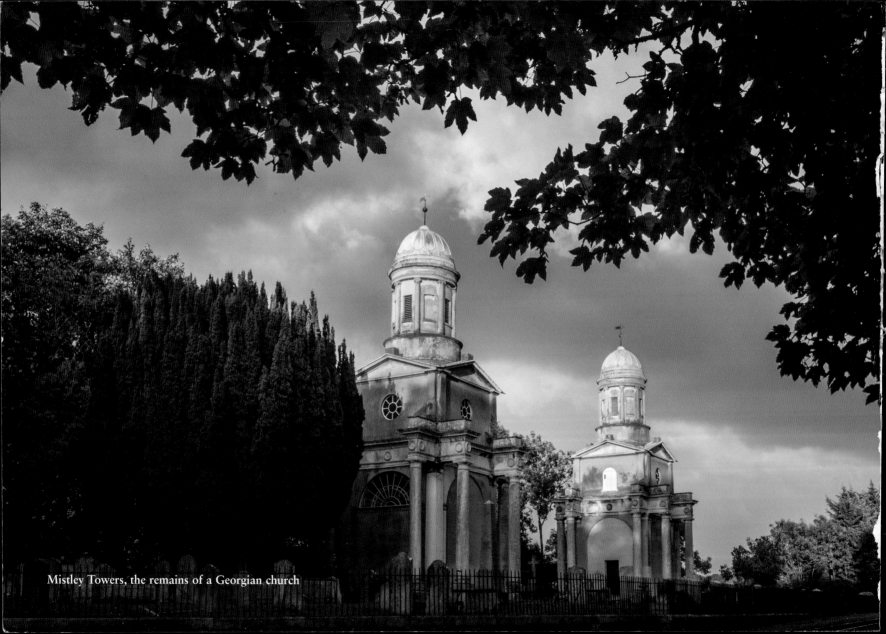

Mistley Towers, the remains of a Georgian church